# YOUR
# DIGITAL
# CAMERA
# MADE EASY

## a beginner's guide

Jackie Sherman

**AGE**
*Concern*

Published in 2007 by Age Concern Books
1268 London Road, London, SW16 4ER, United Kingdom

ISBN: 978 0 86242 424 4

A catalogue record for this book is available from the British Library.

Edited by Ro Lyon
Page and cover design by Nigel Soper
Typeset by GreenGate Publishing Services, Tonbridge, Kent
Printed and bound in Great Britain by Bell & Bain Ltd, Glasgow

# About the author

Jackie Sherman is the author of Age Concern's bestselling titles *Getting the most from your computer* and *Everyday computer activities*, and the IT agony aunt for the website www.laterlife.com. Although an expert on computing, Jackie came to digital photography quite recently, and so is keenly aware of the challenges people face when getting to grips with new technology. She lives in Abingdon, Oxfordshire, with her husband Graham and teenage sons Toby and Will.

# Acknowledgements

The author and publisher would like to acknowledge all the organisations who kindly granted permission to include illustrations from their websites. Our thanks go to Dave Mackin for his invaluable technical help and to Ro Lyon for her excellent editing. An acknowledgement and a big thank you are also due to those who contributed to the illustrations: Janie Airey, Keith Hawkins and, in particular, Daniel Sprawson.

# Contents

# Introduction

Many of us have enjoyed taking pictures since childhood, but the digital age now offers a completely new and exciting experience. You may be very attached to your old camera, but once you've taken a few pictures with a digital camera, you won't look back!

* Have you ever had a holiday or special trip spoiled because you ran out of film just when that wonderful photographic opportunity presented itself? Well, it's quite liberating to know that you will never have to buy another roll of film again.
* Do you worry about wasting precious film? Now you can keep taking as many shots as you like without any worries. That's because the pictures are stored electronically on reusable memory cards and you can delete unwanted images over and over again to make space for more.
* Are you ever afraid that your only copy of a precious photo might fade or get scratched and torn? Storing pictures on your computer means that they are always available, and there are excellent long-term storage solutions if you want to keep them safely for many years.
* Do you hate sending off a roll of film and having to wait for your pictures to be returned through the post? Now you can view them on-screen and take prints – either in colour or black & white – instantly, whenever it suits you.
* Have you ever been disappointed when your pictures come back and you find the one of your new grandson has part of his head missing? One great advantage of digital cameras is that you can check each picture as soon as it is taken and keep taking more until you have one that looks exactly right.
* Do you sometimes want another copy of a particular picture or an enlargement at a later date but cannot find the negatives? If you store the images on your computer, you can run off new copies whenever you want them.

✻ Do any of your pictures end up as disappointing or even disastrous failures? With digital images you can use editing software to improve the composition, colour, brightness and other features of your pictures before they are eventually printed. You can even remove unwanted objects with a few clicks of the mouse. Just by learning a few simple tricks you will be able to produce pictures that look impressively professional.

✻ Would you like to make more use of your photos or share them with distant friends or relatives? Having your own pictures stored on a computer means you can send them by email or on a CD and can easily add them to documents, publications or even publish them on the World Wide Web.

With anything new, there are certain skills that need to be learnt. However, modern digital cameras are far easier to use than the conventional 35mm cameras you might be accustomed to. Most of them have an automatic or fixed focus, and if you rely on the built-in settings you will still produce pictures that are perfectly acceptable for any but the most ambitious photographers. Although this book will introduce you to some of the more advanced features of your camera, as well as programs that allow you to manipulate images, you will find that the actual process of taking pictures is relatively straightforward. Once you have taken your photos, if all you want to do is print them and stick them in a photo album, you can do so without bothering with them again.

## Basic equipment

To take complete control of the photographic process, you will need three major pieces of equipment: a digital camera, a computer and a printer. Fortunately, many of us now own at least one computer and printer, and the cables that are needed to transfer the images onto a computer – as well as the basic software programs that will allow you to view and print your pictures – will be provided when you buy the camera. As long as you check that your computer and printer are modern enough to support the camera and have enough memory for handling images, you should find that in most cases your current equipment is perfectly adequate.

If you do not own a computer or printer, you can actually get by with only the camera. Although you won't be able to make any changes to the pictures beforehand, the removable storage medium (memory card) used in place of film can be taken directly to a print shop if you just want to produce hard copies. Some print shops have machines that will enable you to carry out some basic editing before the pictures are printed.

It is only if you want to manipulate and edit your pictures to a large extent, or produce sophisticated printed images that you will need to buy a computer, more expensive image-editing software program or a photo-quality printer.

## About this book

This book gives impartial advice on what to look for when buying a camera and describes how digital cameras work. It explains the meaning of the technological jargon you will meet and takes you through the process of taking photos, transferring them onto your computer, making changes, printing copies, using them in a variety of ways and storing them safely and conveniently for future use.

It assumes that you have no knowledge of how digital cameras work or what to do with the images once they are on your computer. However, it cannot provide an introduction to computers as such, and so does assume that you have a basic knowledge of how to open, save and edit computer files and how to print off copies of your work.

Although there are professional models available involving SLR (single lens reflex) technology, most people start off with a straightforward compact digital camera and so only this type of camera is described in any detail. There are many cameras and software programs available, and the examples shown in this book were produced using a *Fujifilm FinePix* mid-range camera and software, including *FinePix Viewer, Ulead Photo Express, Corel Paint Shop Pro, Adobe PhotoShop Elements* and *Photo Deluxe* software. The computer used has a Windows XP operating system.

Fortunately, digital camera controls, as well as the menus and tools available in most image-editing programs, all work in a very similar way. You should therefore be able to apply the techniques described in this book easily to your own equipment or software products.

> As digital cameras are so small and light, make sure you have yours with you at all times.

With the help of this book and lots of practice, you should find that you get great enjoyment from using your camera and that your pictures just keep getting better.

# How digital cameras work

Rather like a car driver who doesn't want to know what goes on under the bonnet, you may just want to take pictures and not care about the technology underpinning your camera. If that is the case, don't bother with this chapter at all. However, if you would like to understand how digital cameras work and what makes them different from conventional cameras, read on for a simple explanation.

## Image sensors

When a digital photograph is taken, light enters the camera through the lens aperture and shutter (just as in a conventional camera). But instead of using film, the light falls on an image sensor that is made up of an array of thousands of light cells. The sensor samples the light and converts it into electrical charges which are then converted into digits. These are processed to produce a final digital image which is stored in the camera's memory.

There are two main types of image sensor in today's cameras: a charge-coupled device (CCD) or a complementary metal oxide semiconductor (CMOS) chip. Although there are differences in how they work, they both do basically the same job and it depends on the manufacturer which sensor is used.

An image sensor

The receptors (or photosites) on the sensor only measure monochrome light, but a series of filters are used to enable them to respond to one of the primary colours of light (Red, Green and Blue, often shown as RGB); it is these that are mixed to create all the other colours. Each photosite ends up representing a single coloured dot in the picture, which is known as a 'pixel' – short for picture element.

To understand pixels, think of a painting by Seurat who used a style known as 'pointillism' to paint pictures essentially composed of coloured dots. From a distance, you can make out the different objects in the picture quite distinctly as your eye runs the colours together to make sense of them. As you get closer, you see the objects as thousands of individual dots of colour.

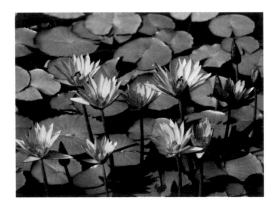

When an image has been enlarged too much the pixels show up clearly

## Resolution

The amount of detail in the picture produced by a digital camera depends on its resolution, which is a measure of the number of pixels for a given area.

This can be expressed as its horizontal by vertical dimensions in pixels (for example 640 x 480) or by the actual number of pixels in the image (for example 307,200).

A resolution of 1216 x 912, for example, creates an image with 1,108,992 pixels – in other words, a megapixel (one million pixels) image. So a 4-megapixel camera will produce pictures with a resolution of 2272 x 1704 containing around four million pixels. A top-of-the-range 11.1-megapixel camera will produce pictures containing 11 million pixels.

In general terms, the greater the number of pixels, the higher the resolution and so the sharper, and more detailed, the picture will be. However, this will also mean a larger image file size. If you won't be printing your pictures, you can set your camera to take lower resolution pictures so that you will be able to fit more in the memory.

The 'optical resolution' of a camera is the actual physical number of pixels that it can produce, and cheaper cameras cannot capture nearly as many as the better models. Some cameras try to increase resolution by filling the gaps with extra pixels (known as 'interpolation') that match the colour or intensity of those nearby. This doesn't mean the picture quality necessarily increases, so always check the optical resolution of any camera you want to use.

The important point to note about pixels is that they do not change in number. When you want to print out a digital photo, there will therefore be a limit to the size of the print you can produce before it starts to look grainy or 'pixelated' – in other words, the dots of colour become visible as small squares as in the picture opposite.

## Memory

The final images that you take are normally stored on removable storage media (memory cards) rather than fixed memory. Memory cards are small and light and they can become damaged. But it is the usual practice anyway to transfer images you want to keep onto your computer and then delete the unwanted pictures so that the memory is freed up for storing new images.

In the past, some digital cameras stored pictures on 3.5" floppy disks, but these required much larger cameras so they have now been virtually discarded in favour of light, small memory cards.

> Each camera will only be able to use one (or possibly two) different types of card, so make sure that any extra cards you buy are of the same type.

Different manufacturers have produced different memory cards, but they all work in the same way – they are small cards that slot into the camera and can store anything from 4 to over 2,000 images. If you want more memory than came with your original camera, you will find you can buy different sizes of card (depending on your budget). Common sizes include 128MB, 512MB, 1G and even 8GB.

In general terms, if you take 4-megapixel pictures you will be able to store about 60 pictures on a 128MB card and over 500 pictures on a 1GB card.

The names of the various types of memory card that you may come across include:

* Compact Flash
* XD Picture Cards
* Memory Sticks
* Secure Digital (SD) Cards
* MultiMedia Cards (MMC)
* SmartMedia Cards
* Microdrives.

## Lenses

Camera lenses focus the image. Digital camera lenses are very similar to those in conventional cameras, but as image sensors are smaller than a frame of film, digital cameras need high-quality lenses to direct the light onto the sensors accurately.

Light enters the camera through the aperture. In digital cameras, the aperture is usually set automatically, although you may find there are manual settings you can access if you want to take more control.

The length of time that light is allowed to pass through the aperture is controlled by the shutter speed and, again, this is digital rather than mechanical. It does mean that, with some slower cameras, you may experience a slight shutter 'lag' after you press the release button, while the camera is preparing to take the shot.

> Some cameras may come with 'burst mode' which lets you take five or six pictures quickly – worth looking out for if you like to take action or wildlife shots.

At the lower end of the price range, digital cameras tend to be 'fixed focus', with a non-moving lens preset to focus at a certain range. More expensive cameras use an automatic focus, which automatically focuses the camera at your subject. Many, of course, will also allow you to set the focus manually.

The distance between the lens and the sensor is the 'focal length' of the camera. Increasing this will increase the magnification. You may find that there is a '35mm equivalent' rating, which gives you a better idea of a camera's range. A normal 35mm camera lens is where the focal length is approximately 50mm – this gives a field of view that corresponds to our normal vision.

The best cameras offer a wide range of focal length from wide-angle (a 'short lens', good for taking landscape shots or pictures of large groups of people) to telephoto (a 'long lens', useful when taking pictures of subjects in the distance). You can change magnification by zooming in or out.

Some cameras also offer 'macro focusing' that allows you to take pictures very close-up that are still in focus.

## Batteries

When using conventional cameras, the main worry was having enough film. With digital cameras involving so much processing, it is the battery life that becomes important. This is because, in constant use, the batteries do not usually last more than a few days and so you always need to have replacements with you.

You can normally use Ni-MH (nickel metal hydride) or the cheaper normal alkaline batteries. But a few cameras use lithium batteries that have a longer shelf life but do not come in standard sizes and can be expensive.

It is much cheaper to use rechargeable batteries and most cameras use these or standard AA batteries which you can replace with rechargeables.

Take the batteries out if you are not going to use the camera for some time.

## Screens and menus

On the back of the camera, or occasionally on a fold-out arm, there will be an LCD screen (LCD stands for Liquid Crystal Display). This will show you the picture you are composing; in other words, it acts as a second viewfinder or, in rare cases, the only one.

One great advantage of the LCD is that you can preview pictures you have taken straight away, if you set the camera to playback mode.

viewfinder

LCD screen

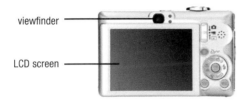

A typical digital camera from the back

The LCD screen and playback mode take up a great deal of battery power, so use them both sparingly if you're out and about.

The camera will have a range of options available, which will include changing the display on the LCD screen and setting the type of image you can take (for example for self-timing or macro focus). You will be able to change settings by clicking a button or selecting the option on a mode dial. Most digital cameras nowadays also allow you to take short video clips as well as still photos and these can be shown on TV screens.

The mode dial on a camera

When you have previewed the pictures, you can use the menu on the camera to delete unwanted images as well as add details, such as the date and time your pictures are taken.

# Buying a camera

There is a wide choice of cameras available nowadays, ranging in price from £30 to £3,000 and offering a dizzying variety of features. If you are thinking of buying a camera, don't worry too much about the extras if your budget won't stretch, as even very cheap models will allow you to 'point and shoot' and produce excellent pictures. But it's useful to know what to look out for when visiting a camera shop or browsing over the internet so that you get value for money and the best camera for your needs.

## Types of digital camera

There are many different types of digital camera. These include:

* Ultra-compact cameras, which will fit easily in a pocket so that they can be carried everywhere
* Compact cameras, which are a little too big to fit a normal pocket, but are still relatively small and light
* More complex cameras, with a wider range of controls
* SLR cameras, which are larger and heavier, have interchangeable lenses and a wide range of accessories
* Mobile phones with built-in cameras.

Digital cameras look remarkably like conventional 35mm cameras, and there is such a wide range available that you should be able to find one to suit any budget. All the names you may associate with cameras, lenses and film, such as *Sony, Canon, Kodak, Fujifilm* and *Leica,* now offer digital products and the quality, as you would expect, is normally excellent.

> If you can, test a few in a shop before you buy, as their size, weight and the convenience of the various features will all vary considerably.

In the shop, handle the camera to feel the weight and see how comfortable it is to hold. Then check how easy it is to turn the mode dial or find options on the menu. Try zooming in and out. You'll need to check that the viewfinder makes it easy to set up a shot and that the LCD screen is large enough to view your pictures clearly.

## Resolution

As we saw in the last chapter, the quality or resolution of your pictures is related to the number of pixels (or small dots of colour) that make up the image. The more you enlarge a low-resolution picture, the more likely you are to see these 'dots'. So if you want to produce very large prints, you will probably need at least a 6-megapixel camera, which will take pictures containing 6 million pixels. If your budget is tight, you will probably find that a 3-megapixel or 4-megapixel camera takes pictures that are perfectly acceptable and you will certainly be able to produce good quality 4" × 6" prints.

At the time of writing, the price of 3-megapixel cameras starts at around £40, and even 5-megapixel cameras from well-known manufacturers can be purchased for as little as £80.

## Memory cards

Different types of card vary slightly in price but as a rule, the bigger the memory the more you pay. When buying extra cards, you should be able to get a 128MB card for about £10 and a 1GB card for around £20 to £30. A 1GB card should allow you to store 500 pictures if taken with a 4-megapixel camera.

## Lenses

It is important to think about the lens in your camera. Lens quality – even on cheap cameras – varies widely, so going for an established name should give you some confidence.

The 'optical zoom' is a measure of the optical magnification. Most cameras offer a stated optical zoom capability of 3x or 4x, but some manufacturers

also quote a 'digital zoom' which attempts to emulate zooming by enlarging a portion of the image electronically. As this can result in poor image quality, make sure that it's the optical zoom you check when buying a camera.

## Batteries

The batteries can run out quickly, especially if you use the LCD screen a lot, so it can be useful if you find a camera that has a battery indicator that tells you how much life is left.

When it comes to buying batteries, many people feel that lithium batteries are the best, but always check the manual first, to make sure a particular type of battery is acceptable.

Take care if the camera you are thinking of buying doesn't take a rechargeable battery, as these are so much cheaper to use. With many purchases, the pack will include a rechargeable battery and a charger, as well as a set of disposable batteries to start you off. Many digital cameras also come with an AC adapter (mains power supply) which will save battery life when transferring images onto your computer via a cable, taking indoor shots or viewing your photos on a TV.

## ISO rating

The more sensitive the 'image chip' or sensor, the less light is needed to take a good shot – similar to a higher-speed film in conventional cameras. The sensitivity is shown by its ISO number. A camera rated ISO 100, for example, has about the same light sensitivity as a traditional film camera loaded with ISO 100 film. Higher ISO ratings mean the camera is more sensitive to light and can take pictures in darker settings, but lighter settings may result in more of what is called 'noise', with pictures looking grainy.

> Most modern digital cameras have adjustable ISO ratings. So look for one offering a wide range of settings; perhaps between 100 and 800.

## Flash

Digital cameras usually have a built-in flash which will automatically sense if flash is needed. More advanced cameras may have extra flash features, such as red-eye reduction or night portrait mode for long exposures. Some will have a 'hot shoe' that allows you to attach external flash units. All beginners need to know how to set the different flash options, as the automatic setting is not always appropriate.

## Screen

The size of the LCD screen can vary considerably – with some going up to 2.7 inches – so check if it is large enough for your needs. This is particularly important if the camera does not have a separate, optical viewfinder but always requires you to look at the LCD screen when setting up a shot.

## Image stabilisation

This is a feature which may be important to you. Also known as 'vibration reduction', the technology helps to compensate for any camera shake that occurs when a picture is being taken. Tiny gyroscopes within the lens help to eliminate, or at least reduce, the blur that camera shake can create.

## Other accessories

As well as the basic camera, you may want to check whether there are special offers on any other items, such as a case – preferably waterproof for outdoor photography – tripod, battery charger, card reader or a particular image-editing program that you want to use.

## Comparing prices

Many people like to go to a shop to get advice and make their purchase. However, once you have decided what features you need and what your budget is, you can also use the internet to read reviews, compare prices and buy your camera.

The various websites worth visiting include retailers, such as **www.amazon.co.uk** or **www.jessops.co.uk**, or comparison sites, such as **www.shopping .com**, **www.bizrate.co.uk** and **www.kelkoo.co.uk**

Comparing the price of cameras on a shopping website

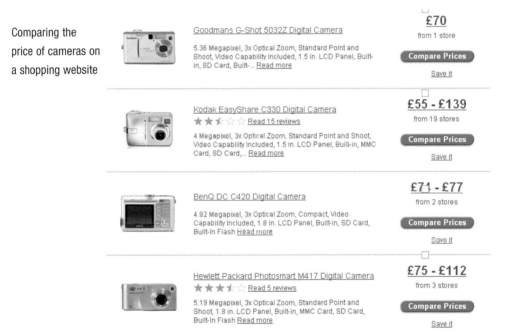

Goodmans G-Shot 5032Z Digital Camera

5.36 Megapixel, 3x Optical Zoom, Standard Point and Shoot, Video Capability Included, 1.5 in. LCD Panel, Built-in, SD Card, Built-... Read more

**£70**
from 1 store

Compare Prices

Save it

Kodak EasyShare C330 Digital Camera

★ ★ ⯪ ☆ ☆  Read 15 reviews

4 Megapixel, 3x Optical Zoom, Standard Point and Shoot, Video Capability Included, 1.5 in. LCD Panel, Built-in, MMC Card, SD Card,... Read more

**£55 - £139**
from 19 stores

Compare Prices

Save it

BenQ DC C420 Digital Camera

4.92 Megapixel, 3x Optical Zoom, Compact, Video Capability Included, 1.8 in. LCD Panel, Built-in, SD Card, Built-In Flash Read more

**£71 - £77**
from 2 stores

Compare Prices

Save it

Hewlett Packard Photosmart M417 Digital Camera

★ ★ ★ ⯪ ☆  Read 5 reviews

5.19 Megapixel, 3x Optical Zoom, Standard Point and Shoot, 1.8 in. LCD Panel, Built-in, MMC Card, SD Card, Built-In Flash Read more

**£75 - £112**
from 3 stores

Compare Prices

Save it

Several websites now include camera buying guides that allow you to select all of the features you feel you would like. They then display a range of models meeting your particular requirements. Two such websites worth checking are **www.dpreview.com** and **www.cameras.co.uk**

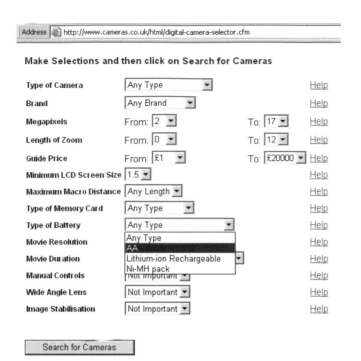

Address 🔲 http://www.cameras.co.uk/html/digital-camera-selector.cfm

**Make Selections and then click on Search for Cameras**

| | | |
|---|---|---|
| Type of Camera | Any Type ▾ | Help |
| Brand | Any Brand ▾ | Help |
| Megapixels | From: 2 ▾  To: 17 ▾ | Help |
| Length of Zoom | From: 0 ▾  To: 12 ▾ | Help |
| Guide Price | From: £1 ▾  To: £20000 ▾ | Help |
| Minimum LCD Screen Size | 1.5 ▾ | Help |
| Maximum Macro Distance | Any Length ▾ | Help |
| Type of Memory Card | Any Type ▾ | Help |
| Type of Battery | Any Type ▾ | Help |
| Movie Resolution | Any Type | Help |
| | AA | |
| Movie Duration | Lithium-ion Rechargeable ▾ | Help |
| Manual Controls | Ni-MH pack | Help |
| | Not Important ▾ | |
| Wide Angle Lens | Not Important ▾ | Help |
| Image Stabilisation | Not Important ▾ | Help |

[ Search for Cameras ]

A website that allows you to select the camera features you need

If you don't have access to the internet, you will find reviews of digital cameras in camera magazines, such as *Digital Camera Magazine.*

## At the end of this chapter you should be able to...

♦ If you have already bought a camera, confirm what type it is in terms of:

– megapixels
– optical zoom
– batteries
– memory card type and size.

♦ If you are thinking of buying one, visit a search engine site and compare some cameras in your price range. In particular, check the four aspects listed above.

# Getting started

As each camera model is unique, you do need to familiarise yourself with the manual that will have been supplied – either in print form or on a disk. But this chapter provides general guidelines that will give you a good idea of what is involved so that you can feel pretty confident with your camera. It explains the basics of getting started with taking pictures. It also tells you how to change the settings on your camera, as well as changing the batteries and memory cards and printing photos.

## Getting to know your camera

When you open the box containing your new camera, you will normally find the following items:

* The camera
* A manual (unless this is stored on a disk)
* A CD-ROM containing both the software needed to transfer your pictures onto a computer and an image-editing program
* A cable to connect the camera to your computer
* Extras – such as a case and battery charger.

Inserting the memory card

Before you can use your camera, you will need to load the batteries. The memory card will also need to be pushed into its slot, making sure any markings on the card are lined up correctly.

# Taking your first picture

For normal pictures – when the object is usually more than 2 feet away – make sure that the mode dial or button is set to still photography (this is sometimes shown as the outline of a camera) as opposed to the movie setting. Switch on the camera by sliding or pressing the power button.

If you are new to photography, you will find that using your camera at its simplest – relying on all the automatic settings – is just a question of 'point and shoot'. All you have to do is:

1   Aim at your subject.
2   Check the composition in the viewfinder or on the LCD screen and increase the zoom, if necessary, to frame the view attractively.
3   Press and hold down the shutter release button halfway to lock the focus. (The LCD screen of your camera may have a small autofocus frame for centring the focus.) Sometimes the centre of the picture does not contain anything to focus on, so move the camera until an object is in the centre of this frame.
4   Once the focus is locked, you can move the camera back into position.
5   Press the button down fully when you are ready to take the picture taking care to hold the camera steady. (If it is needed, you will find that the flash fires automatically.)

For tall objects, turn the camera on its side – you can easily rotate the image once it is on your computer if you want to work on it or print it out horizontally.

One difference you will notice with some digital cameras is that the shutter does not 'click', making it difficult to know that you have actually taken a picture. When you review your pictures later it will soon become clear if one was not taken. If in doubt, take another photo, but you will find that you get used to the change very quickly.

If you leave it for too long, you may find that your camera uses a power-save function and has switched off. It will come back on again at the touch of a button, but it is a good idea anyway to turn off the LCD screen when it is not needed. Just turn it back on again when necessary.

## Avoiding camera shake

With any camera, it is very important to hold it still or your pictures will suffer from camera shake. Some cameras have fixings for a special camera stand – the tripod – and there are now small tabletop tripods available that are much easier to carry around than the normal sized equipment.

If you don't use a tripod, make sure that the camera is held firmly in position or rested on a stable surface, and that there are no fingers or other objects in the way of the lens.

## Taking your camera out with you

When going out for the day, you may want to take spare batteries and a spare memory card if yours is small. Capacity is always an issue in digital photography, because you often want to take lots of photos in one day – perhaps at a wedding or child's birthday. One question is – should you go for one 4GB card, or four 1GB cards? A larger capacity card means you won't have to change it for the whole day. But, if something goes wrong, you would lose every photo. So, generally, it's a good idea not to have all your eggs in one basket.

> **Check before you go that your memory cards have some space, deleting unwanted pictures and saving others onto your computer beforehand.**

# Checking the pictures

The forward and back buttons (which can have diffferent functions in other modes) allow you to look through your photos

You can keep taking pictures as long as you want to but it's a good idea to check what they look like in the LCD screen now and again by using the 'playback' facility. To do this, turn the mode dial to the correct setting (it usually shows a backward facing arrow), or click the playback button, and work through the pictures using the forward or back button. There may be a zoom function to allow you to view your picture in more detail.

# Changing the settings

All digital cameras have a menu of options available, as well as various buttons and dials, and they usually offer the same main facilities. To access them, press the 'Menu' button and then use the up, down, left and right arrows to scroll through the various settings. When you want to select or apply one, press the 'Menu' or 'OK' button.

A camera's menu showing on its LCD screen

## Date and time

It is very useful to have date and time details on your pictures. If you save the pictures onto your computer in a hurry, they will be identified by these details. If you choose to date stamp your actual prints, you will be able to see in which month or year your photos were taken.

Setting the date and time

When you select the date and time option from the 'Menu', you can use the forward button to move between day, month, year and time and then press the up or down buttons to change the entries. (Some cameras will use a 24-hour clock, or you may need to confirm that it is morning or afternoon.)

When the date is correct, press 'OK' to fix the settings and exit the Menu. Your picture files will now show these details correctly. Your camera may also offer the option to add the date and time in a corner of the photo.

# Changing batteries

As already mentioned in earlier chapters, you are likely to need to change the batteries quite often if you use the camera constantly. You will also want to recharge your batteries regularly if using rechargeables.

Try to make the changeover fairly quickly so that settings, such as date and time, do not need to be reset.

Simply open the battery case and slip out the batteries to remove them, making sure that any replacements are always of the same type.

---

Never change the batteries when the camera is turned on, as this may corrupt the images on your memory card.

---

## Changing memory cards

Memory cards tend to be on a spring so, to remove one, press down gently on the top of the card. It should then pop out when you remove your finger.

## Printing

Although we are in the digital age, you can still visit your favourite high street photographic shop and order prints. Nowadays you no longer have to wait a week or pay extra for a faster service. You can take in your camera or memory card and view, select and even carry out basic editing on the pictures you want, then print them out instantly. Of course, if you prefer, you can still leave the pictures with an assistant and pay for the one-hour or 24-hour option. There will be a choice of print size as well as the type of paper used (for example glossy or matt).

An interactive screen from Kodak's Self-Service Picture Maker

As well as the usual stores such as *Boots, Jessops* or *Snappy Snaps,* you will now find kiosks such as *Kodak Self-Service Picture Maker,* in a range of retailers (including mobile phone shops). Push your memory card into the slot and choose ordinary prints or a CD of photos (or both) to take away. A CD is useful if you want to save time and store your photos safely until you are ready to view or print them out at a later date. You can 'upload' photos from all types of memory card, disks and even your mobile phone.

If you have access to a photo printer and suitable photographic paper, you can either connect the entire camera directly to the printer, or slot in the memory card, and print out your own pictures.

There is usually an index print facility to help you select your photos and a simple menu system for cropping, adjusting colour and changing layouts.

A photo printer

# Deleting unwanted pictures

If you have had a long photographic session, you may want to delete unwanted pictures straight away, so that there is room for more on the memory card.

You can do this by locating any unwanted pictures in playback mode, pressing the 'Menu' button and selecting the 'Delete' option for that frame. If you press the 'Back' button, this should let you leave the menu and carry on viewing your pictures.

## Formatting the memory card

If you have spent all day taking pictures, you may not want to waste time deleting unwanted photos individually. Instead, once you have stored or printed the images you do want to keep, you can wipe the memory card and remove the remaining unwanted pictures completely.

To do this properly you need to 'format' the memory card. This will prevent it from becoming corrupted. Formatting, also known as 'initializing', overwrites *everything* on a card – including protected images, directories and camera data – and sets up new folders and data on the card ready for your next session.

## At the end of this chapter you should be able to...

♦ Change your camera's batteries and memory card.

♦ Set the date and time on your camera accurately.

♦ Take a few shots and then play them back.

♦ Use a do-it-yourself photo kiosk to print out some pictures.

♦ Delete your unwanted pictures.

♦ Format the memory card.

# Taking pictures

Now that you've started using your camera, you'll soon want to get the most out of it and make sure that all of your pictures come out really well. This chapter explains how to take control of your camera and produce better quality photos. It gives hints on composing your photos and explains how to make best use of your flash, close-ups, manual settings and the self-timer.

## Composition

Whole books have been written about creating a good picture, and exactly the same rules apply to digital as to conventional cameras. Although the image-editing programs can do wonderful things to put right mistakes, always aim to take the best picture you can, so that as little editing as possible will be required. This may mean waiting for the light to change or getting yourself into an awkward but better position, but it should be worth the effort.

Here are some golden rules for composing the best pictures:

1   When photographing people in bright sunlight, remember that facing the sun will force them to squint. Also, face on, shadows will look very dark.
2   If you have to photograph directly into the sun, protect the lens from glare and take care of your own eyes when using the viewfinder. It may also damage the sensor if you spend too much time with the camera pointing at the sun.

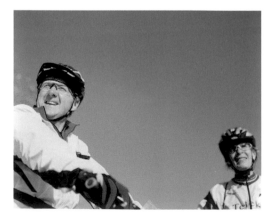

Taking a great picture in full sun

3   For landscapes, choose the time of day carefully, as it will make a great difference to the light and shadows. The beginning or end of the day, as long as there is enough light, are often very good times for photography; they tend to give greater depth and lovely colours. The bright, midday sun can make pictures look flat and less interesting.

It's worth waiting to capture the animals in the dawn light

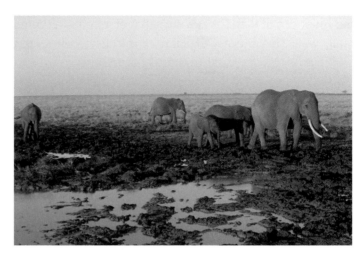

Something's missing…

4   Take great care that a vital part of your subject is not missing from the shot.
5   Unless aiming for an unusual picture, try to be at head height – you may need to crouch down when taking pictures of small children or animals. When taking photos of tall buildings, aiming upwards may make it look like the buildings are leaning backwards.

An unusual angle can make for a lovely picture

6 Set up your main subject against a good background, so that a bright or unusual object doesn't take away all the attention.

Don't let an unwanted object hijack your shot

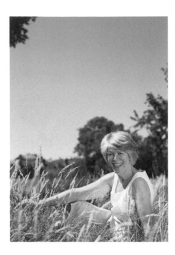

The grass in the foreground 'frames' the shot

7 It can often improve the picture if you include a flower, arch or tree branch near you to 'frame' the shot.

8 With autofocus, check what the camera is focusing on as it may be something in the foreground or background, and not your main subject.

9 Size matters – use the zoom or move closer if your main subject doesn't fill the picture frame sensibly.

10 As you know, being asked to smile can produce stilted, uncomfortable photos. Sometimes it's best to take people by surprise when they are talking or smiling naturally.

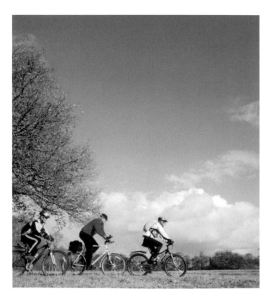

Using the zoom would have brought these cyclists closer and cut down on the amount of sky

11 Children and animals won't wait for the perfect shot, so take their photos quickly, even if these aren't set up just as you would like.

With a digital photo you can keep snapping away – chances are you'll end up with at least one really good shot

A balanced lanscape shot

12 For landscapes, remember the artist's rule of 'thirds': keep the horizon a third from the top or bottom of the picture, and a vertical object a third in from the left or right.

13 Don't expect miracles from the flash. It can only illuminate within a certain distance and will emphasise the contrast between the brightly lit foreground and darker background. It may need to be turned off if, for example, you want to take pictures of bright objects such as fireworks or Christmas tree lights.

The person in the foreground shows up clearly, but the background is dark

# Self-timer

It's good to have the photographer in the picture occasionally as well as the rest of the family! That is when a self-timer comes into its own, as a helpful passer-by may not always be available to take the shot for you.

To put yourself in the picture:

1   Set the mode dial to the self-timer option (which may show as a little clock) and then set up the shot carefully.
2   If you haven't got a tripod, find somewhere stable to rest the camera and then look through the viewfinder to frame the shot in the same way as you would take any normal photo. Remember that you will be adding another person – yourself – to the frame, so keep the camera aimed at the centre of the final grouping.
3   When everything is ready, hold down the shutter halfway to set the focus and then press it down fully.
4   Once you press the shutter button down fully in this mode, you will only have around 10 seconds before it is released. Make sure you don't knock the camera as you move away.
5   During self-timing, the camera lights may blink or flicker and you may hear beeps, but remain still until you are sure the picture has been taken.

# Macro photography

The 'Macro' setting is great for pictures of flowers

We often want to magnify objects and take close-up pictures of flower petals, insects or pictures from a book or magazine article. With conventional settings it would be impossible to focus properly. Fortunately, many digital cameras offer what is called a 'Macro' option  that can work effectively at distances of 10cm to 80cm, as the lens is fixed at the wide-angle zoom setting.

When preparing to take a picture, remember that the optical viewfinder on most cameras is situated above the lens and so the field of view will not match the actual picture that will be taken. In these situations, a more accurate image will be the one seen on the LCD screen. To frame the shot, move the camera closer or further away, rather than using the zoom, as the macro settings are based on the normal lens position.

Most photographers would recommend using a tripod to keep the camera steady, especially if taking pictures in low light; the camera will be so close to the subject that the slightest movement will result in image blur. You can also set the self-timer so that you don't touch the shutter and jiggle the camera at the last minute.

> You often need to use the flash for extra illumination, but one tip for close-ups is to diffuse the light by holding a piece of paper over the flash, which cuts down on the 'washed out' effect that can otherwise result.

If your object won't move, another tip from the professionals is to make sure that the camera focuses on the correct details by blocking off surrounding objects with clean, white paper. Having locked the focus by pressing the shutter down halfway, remove the paper during the 10-second final countdown and the focus will remain centred on your object.

> Remember to change the mode dial back to normal when you have finished your close-ups – or future photos will look very odd!

## Flash

A typical flash on a digital camera might have a range of about 12ft (4m). Subjects close to the camera will be brightly lit, while those in the background will appear very dark.

> You should be able to turn the flash off if you feel the picture would be better in this mode. An even simpler solution for some pictures is to put your finger over the flashbulb as you take the shot.

There may also be other settings, depending on the sophistication of your camera, which you can use to correct various problems. Simply press the flash button to toggle through the settings for each picture. These will be shown by a changing symbol on the LCD screen.

## Red-eye reduction

When taking pictures of people or animals, this flash setting will help when there is low light. It minimises the red-eye effect caused by the light of the flash being reflected off the back of the eye.

The flash fires a pre-flash, or series of short flashes, first of all to make the pupils contract just before the picture is taken.

Red-eye – a common problem with portraits

> You can also cut down on possible red-eye by making sure you are as close as possible to your subject and that they look directly at the camera.

## Forced (fill) flash

To help when taking pictures that are backlit – for example when someone is in front of a window or bright sky or in the shade of a tree – you can use this setting to avoid very dark objects or shaded faces. It fires even when the scene is very bright and so will illuminate the objects that are in front of the camera.

Forced flash was used here to ensure the family group showed up against the sky

### Suppressed (no) flash

For reflective surfaces, photos taken indoors but through glass, or where the subjects are some way away, such as on a stage, the normal flash will not be effective or may not give you the result you want. In these situations, use the no flash setting to suppress the flash and allow the natural colours to be captured.

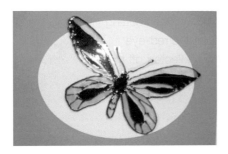
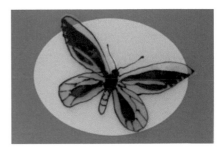

The flash is reflected in the butterfly's wings       But not using surpressed flash

### Night scene mode/slow synchro

This mode uses a slow shutter speed, and is useful for taking pictures at night. Both the subject of your picture and any lights in the background will be clearly shown as the flash will light up the main subject, while the slow shutter speed allows the camera to expose the background.

# Video

Many of even the most basic digital cameras allow you to take a few minutes of video, and some will include sound. But you will need room on the memory card as video takes up a considerable amount of space. Thanks to cheaper and higher capacity memory cards, though, that's less of a problem than it used to be.

> Don't expect a digital camera to fully replace a camcorder. Digital cameras are great for short clips, but you wouldn't use one to record an entire nativity play. It's best for events such as singing 'Happy Birthday' at a party, or the moment your grandson receives his swimming prize.

Companies are now offering 24 – or even 30 frames – per second video, which means that your video will show the full range of motion without the choppiness associated with lower frame rates.

Set your mode dial to video (this may be represented by a film camera icon). Once the shutter release button is down, a recording symbol will show on the LCD screen and you will have a limited time to take your film before shooting ends.

Having taken your video, you can usually play it back on the camera. You can also copy the videos to a computer, where you can show them using a free program, such as *Windows Media Player* or *QuickTime,* that you can download from the internet. You will also be able to edit them or store them on a CD or DVD.

# Manual settings

Once you are more confident with the camera, you may want to take more control, so find 'Set Up' on the menu and then choose the settings you want to amend. (For less sophisticated cameras, these may be rather limited.) Here are some settings you might want to change:

## Aperture and shutter

It's essential to allow the correct amount of light to contact the image sensor: too much and the shot is 'over-exposed' with overly pale, washed-out colours; too little and it is said to be 'under-exposed' with dark, unattractive results.

Aperture and shutter speed work together to achieve the correct exposure: you rarely change one without also changing the other. As the aperture shrinks, the shutter speed must slow to allow more time and to counteract less light entering through the aperture, and vice versa.

The shutter controls movement – both the subject and camera shake – and the aperture controls how much of the scene (from back to front) will be in sharp focus. You may have to decide which is more important, and this will depend on the circumstances and the type of picture you're trying to take.

A moving target is best shot with shutter priority mode

Setting-related modes are either fully automatic (typically described as 'program' mode) or semi-automatic (typically described as 'aperture-priority' mode and 'shutter-priority' mode).

In aperture-priority mode, you decide the camera's aperture setting (the size of the lens opening), and the camera automatically chooses the appropriate shutter speed (the length of time that the shutter is open and the image sensor is exposed). In shutter-priority mode, you decide the camera's shutter speed, and it automatically chooses the most appropriate aperture value.

The camera might also have a variety of modes to choose from, such as sports, portrait or outdoor, which are aperture/shutter speed presets.

## Depth of field

This is the extent of sharp focus between the nearest and furthest elements in the picture, and you can create different effects by changing aperture settings. These are measured in 'f-stops', where higher numbers mean a smaller aperture and longer depth of field.

There are some subjects, especially flowers or portraits, where you might want a shallow depth of field with the main subject standing out strongly from a background that is out of focus. For these, you will need to use a telephoto lens at its widest aperture. You could also try moving the subject as far away as possible from the background.

On the other hand, a landscape photo might be better taken with a small aperture so that you increase the depth of field – both foreground and background will appear sharp.

A picture that focuses on the foreground showing shallow depth of field

In this photo a smaller aperture means that both foreground and background are in focus

## Shutter speed

Slowing down the shutter speed to something like 0.15 seconds or longer will make moving objects appear as a blur and can be used to create night-time pictures; for example where the car headlights join to create streaks of light. One-fortieth of a second is about as slow a shutter speed as you can use when taking a hand-held shot with a wide-angle lens. Faster speeds, perhaps around $\frac{1}{125}$ second, are useful when you want to 'freeze' fast-moving objects.

An action shot comes out well with the correct shutter speed

## Exposure compensation

When your subject is much brighter or darker than its background, you can obtain the best image brightness (exposure) by changing the Exposure Value (EV) setting manually. The number will be larger for bright objects and smaller for darker objects.

On the *FinePix A303* camera, for example, the range changes in 0.3 EV increments from -2.1 EV to +1.5 EV. A good setting for locations such as ski resorts might be +0.9 EV, while for dark forests it might be -0.6 EV.

## White balance

White objects are often quite different colours, especially when the light changes. Daylight, for example, tends to be bluer than incandescent light (light from a bulb).

When you take photos, the camera selects an object that is designated 'white' and then adjusts the colours of surrounding objects accordingly. If the automatic setting does not adjust correctly for the light in a particular situation, you may be able to apply a standard setting. Common settings available include bright sun, shade, incandescent or fluorescent light. You could also alter the white balance manually.

> The white balance setting is ignored when using the flash, so suppress the flash to achieve the desired effect.

These photos were taken in the same place at the same time of day but using different white balance settings

## Image resolution (quality)

Although your camera may be able to take 4-megapixel or 5-megapixel pictures, image files take up far less space if they are shot at a lower resolution, and very often the quality will be quite adequate. For example, images you are going to publish on the Web or send by email need only be at a resolution of 0.3M (640 × 480 pixels) and even pictures to print out on A5 paper will be good quality at 2M (1600 × 1200 pixels).

## Digital Print Order Format (DPOF)

If your camera has DPOF, you can mark certain photos on the memory card with print instructions. This is particularly useful if you want to print large numbers of pictures directly on a photo printer or take the photos to a print shop. If the equipment you're using can support this format, the information is checked and the photos you requested are automatically printed.

## At the end of this chapter you should be able to...

◆ Check through the manual to see what types of flash options are offered, and the symbols that are used for each one.

◆ Take a few shots, repeating the same shots twice. Take the first without much preparation and then again after applying one or more of the rules of good composition.

◆ Try taking a close-up using the macro settings.

◆ Check which manual settings are available and experiment by making a few changes.

# Getting images onto your computer

We have seen that you can take pictures and print them out without needing to use a computer. But digital cameras are made even better because of the range of things you can do with them on a computer. Instead of putting up with the imperfect pictures you took, you can adjust and enhance them and so create far better pictures. You also have much more control over how you share them with others. This chapter explains how to transfer the images to your computer and how to find, view, save, rename and delete them once they are there. Although the examples shown here are in Windows, most cameras will also be supplied with Macintosh software that works in a similar way and with similar options.

## Downloading

Before you can view your pictures, you must install the software programs provided with the camera onto your computer. These will normally be found on an accompanying CD-ROM. If you don't do this first, you won't be able to access your pictures as the camera won't be recognised.

The process of transferring image files from your camera to your computer is known as 'downloading'.

A few cameras use a docking system. The camera is placed in a docking cradle which is plugged into your computer. The pictures are transferred automatically while the dock recharges the camera's batteries at the same time.

Most cameras, though, rely on one of two main methods for downloading the images: you either physically attach the camera to the computer by cable; or you remove the memory card and insert this into a card reader which is itself plugged into a USB port (about the size of a telephone jack) on your computer.

The advantage of using a card reader to access the pictures is that if you or your family own two or more different types of camera, you can buy a multi-card reader that can read a variety of different memory cards.

If you are transferring image files by cable, connect the camera to the correct end and then plug the other end into a spare USB port on your computer before switching on the camera. In a few seconds you will be able to display the files. The correct cable should have been provided with your camera.

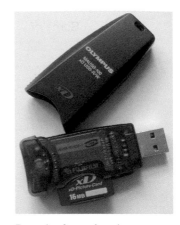

Example of a card reader

As this type of downloading uses up battery power while the camera is turned on, you may want to make use of the AC adapter and plug the camera into an electric socket. This means the camera is powered by the mains during the transfer process.

## File types

Cable to connect your camera to a computer

Most digital cameras store pictures as compressed 'JPEG' image files, which allow you to fit a large number onto a memory card by discarding some of the information in the image. These files are quick to download onto your computer and are the best types to send by email or publish on the web. However, it is important to realise that JPEG is known as a 'lossy' format, because the compression causes the image to lose detail and clarity *each time* the image is saved.

You can save your pictures in a lossless file format when downloading them (see later guidance on saving) but serious photographers prefer to use a camera that takes uncompressed pictures. Your camera may offer a choice of file formats.

Two other formats you may come across are the uncompressed 'TIFF', that produces larger files retaining all of the original detail, or a manufacturer-specific 'RAW' format. This is the pure data as captured on the camera chip without any 'on board' processing. It will normally provide the highest quality file but you will not be able to fit so many into the memory and editing can be more complex.

Some of the main types of image files are summarised for you in the table:

| File type | Description |
| --- | --- |
| **JPEG** (Joint Photographic Experts Group File Interchange format) | Compressed files that are normally used when saving images on a digital camera. As they compress the data, they throw some of it away – technically, this is called 'lossy' compression. |
| **TIFF** (Tag Image File Format) | A popular professional graphics format. |
| **GIF** (Graphics Interchange Format) | These only have 256 colours, or 256 shades of grey. 256 greys is photo quality, so GIF is fine for any monochrome image, but 256 colours is no use for professional colour photos. |
| **PNG** (Portable Network Graphics format) | A lossless, well-compressed format like GIF. |
| **RAW** | A minimally formatted image data file. |

# Locating the picture files

There are several different ways to locate your picture files:

* from your desktop;
* using the 'File' then 'Open' menu option; or
* by 'acquiring' the pictures directly from the camera within an image-editing program.

The picture files will be named generically in the order they are taken – for example DSCF0001, DSCF0002 or P1010101, P1010102, etc. You will need to rename any images that you save to help you find them in future.

## Opening your files

The files will be visible in your directory or filing system on a new drive – usually labelled 'Removable Disk' (E:) or (F:).

To get the files:

1 Double-click 'My Computer' and identify the new 'disk' or 'drive'.
2 The pictures themselves may be stored within folders on the disk, so open these to find the files.
3 Depending on the view, double-click the folder or click the + symbol next to a folder to display its contents.

Close button

Finding your image files

## Viewing your pictures

Assuming you have a Windows machine, use the 'View' menu or drop-down list next to the 'Views' button to change the display from a simple list or icons to thumbnails (small examples). Double-click any picture to see it in full size.

Change the view and select 'thumbnails' to see small versions of your photos

If you have a large number of pictures on the memory card, you may prefer to select 'Filmstrip' as this enables you to use the back and forward buttons to work through the pictures.

Move through your photos with the back/forward buttons in the 'filmstrip' option

With some operating systems, including Windows XP, you also have the option to view your pictures as a slide show where you can sit back and watch your pictures come up, one after the other. Leave the show by pressing the Esc key (top left of the keyboard). A slide show is a good way to show your pictures to other people, but you cannot save or edit them in this view.

Run slide show

Another way to view is offered when you select a picture and go to 'File – Preview'. This opens *Windows Picture and Fax Viewer*. You can then look through the pictures using the arrow keys.

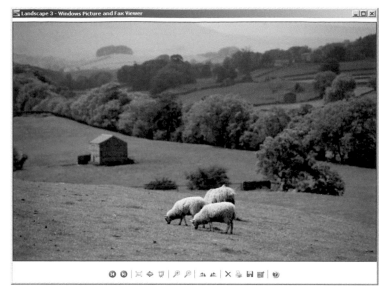

Using Windows Picture and Fax Viewer

You can also use the menu to carry out a range of different tasks:

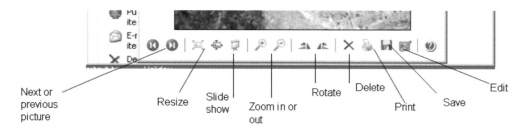

Next or previous picture · Resize · Slide show · Zoom in or out · Rotate · Delete · Print · Save · Edit

When you want to close your program, you can do this by clicking the 'Close' button (showing as a cross in the top, right-hand corner of the window) or by going to 'File – Close'.

## Saving

Once you have taken your pictures, the best thing to do is save them onto your computer. If you leave them on the memory card they will take up space you may need at a later date. It's very frustrating to miss a great shot because your memory is full.

Whenever you find a picture you want to keep, click the 'Save' button or go to 'File – Save' and complete the boxes in the 'Save As' window.

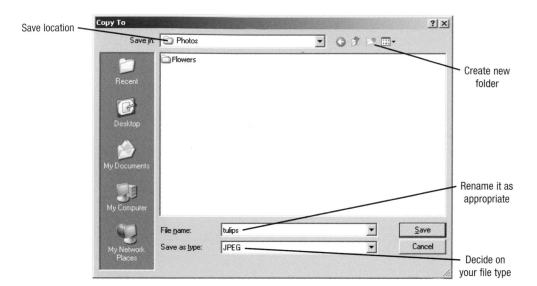

Save location

Create new folder

Rename it as appropriate

Decide on your file type

If you use the task pane and select 'Copy this file', you will have to rename it after it has been saved.

> Make sure you name pictures appropriately, and if necessary create a new folder in which they can be stored. For example, you could have a separate folder for each holiday.

Depending on which program you are using, check that the file type is correct before you click the 'Save' button. JPEG files take up the least room, or you might prefer to archive your images in a lossless format since you never know if you'll need to edit the images for another purpose in the future, (the downside to this solution is the extra storage space required as a result of the larger file sizes).

An alternative method for saving is to drag picture files into folders with the mouse. The filenames will then have to be changed afterwards. If you want to try this:

1   Click the 'Folders' button on the toolbar to show all of the folders on your computer and then use the mouse to drag the pictures across.
2   When the destination folder turns blue, let go and the file will drop inside.

Folders button

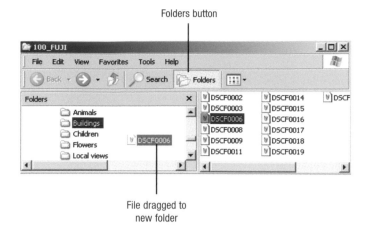

File dragged to
new folder

Always keep a copy of your original pictures untouched, in case
you make mistakes when working on them.

## Renaming

If you copy files rather than renaming them during a normal
save, rename them as soon as you can so that you can find
them again easily.

You may also want to rename files if you spell any words incorrectly or
change your mind about what they should be called.

To rename a file:

1   Right-click any file and select 'Rename' from
    the menu.
2   Type the new name over the blue text in the
    filename box.
3   Press 'Enter' or click the mouse to apply the
    new name.

# Deleting

When you view a picture you obviously don't want to keep, simply select it and press the 'Delete' button on the keyboard or menu.

To wipe the memory card properly, once the important pictures have been saved elsewhere, you should format it in the camera. When viewing pictures on the computer, though, you can also delete all remaining files by pressing 'Ctrl + A' or going to 'Edit – Select All' and then delete them in one go.

## At the end of this chapter you should be able to...

♦ Connect your camera to your computer and locate the pictures you have taken on the desktop.

♦ Double-click a picture to see what program is used to open it and then close it again.

♦ Change the viewing options to see details, thumbnails and a filmstrip.

♦ Set up folders for storing your photos, for example 'Dad's birthday'.

♦ Rename a photo file.

♦ Delete unwanted photos from your camera.

# Image-editing software

To be able to work with your photos, you will need some form of image-editing software. Your camera will always come with a program, usually a fairly simple one, and you can even use *Microsoft Paint*, which is available on all Windows machines, to view pictures and copy them into documents and publications. To carry out more than just basic tasks, though, you will need a proper image-editing program. A wide range, including some good quality programs, may be available free from the internet, or you can choose a commercial package, costing between £50 and £100, that will produce top quality, professional results.

## Software with the camera

Manufacturers will provide software on a disk along with the camera, to make sure you can view and print your photos. For example, the *Fujifilm* camera *FinePix* comes with *FinePix Viewer.* These programs are usually only capable of quite simple tasks.

The disk may include other useful software, such as *Adobe Acrobat Reader* (to read the manual if it is in the form of a PDF file) and *QuickTime* for displaying movie clips. So always install these at the same time as the image-editing software.

It will be worth going through the tutorial or online demonstration that will be available from the menu or as a separate file, as this will explain how everything works.

Familiarise yourself
with your camera's
software

# Free software

If you don't want to buy any extra software but would like to try different
programs for free, you could visit a search engine website on the internet to
find a suitable program, or buy a computer magazine that includes a give-
away CD. Even library books on digital photography often include software
on CDs that you can use freely.

Names to look for include:

∗ *Photo Plus*
∗ *GIMP*
∗ *Ultimate Paint*
∗ *VicMan Photo Editor*
∗ *Photo Express.*

You may also find trial (30-day) or cut-down versions of more expensive
software.

If you find one you like the look of on the internet:

1   Click the 'Download' button on the website. You will be able to save
    the setup file onto your desktop.

Downloading a program from a website (this can take some time)

2   When the download is complete, locate the program on your desktop.

You will find a new icon on your desktop

3   Double-click the icon and the program will be installed on your computer. You will have to accept the licensing agreement and perhaps decide on certain settings, such as the language used, but in most cases you can let it install to the default folder and with the details selected automatically.

4   Launch the program by finding it on your 'Programs listing' – it will usually be at the end of the list – or from an icon if this has been added to the desktop.

Once installed you will find the program listed along with your other ones

With many free programs, the publishers want details of your email address so that they can send you promotional material. They ensure that they have this by making you wait for a special code – the registration key – that is needed to 'unlock' or start up the program for the first time. This will be sent to your email address.

If you prefer, set up a web-based address for this type of information (for example at *Hotmail* or *Yahoo*) rather than giving them the address you use all of the time.

## Advanced software

> If you find the free or cheap versions too limited for what you want to be able to do with your photos, you may decide it is worth buying a proper commercial package. Whatever product you buy, make sure it will work on your computer.

On retail or comparison websites (such as **www.amazon.co.uk**) you will find summaries and technical details showing whether the software works on a Windows or Mac machine, and what version of operating system – for example Windows XP or Vista – and amount of memory you will need.

The most popular image-editing software packages at the time of writing are *Paint Shop Pro* (*Corel*), *PhotoShop* (*Adobe*), *Photorestyle* (*Tesco*) and *Digital Image* (*Microsoft*). Other manufacturers in the photo editing field that have products worth looking out for include *Roxio, Ulead, Serif* and *Xara.* There may also be different versions of the programs offering different features at different prices.

Comparing different image editing programs on the internet (and you can buy them online too)

Once you have bought a particular package, new versions offering extra features will come out regularly, and you can upgrade to these without having to buy another full package. There is often a number next to the software name indicating the version, so that if you want to buy second-hand – on websites such as **www.amazon.co.uk** or **www.ebay.co.uk** for example – you will have an idea of how old it is.

## At the end of this chapter you should be able to...

♦ Open the image-editing program supplied with your camera.

♦ Familiarise yourself with the tools and menus, and take a tour or follow the demonstrations.

♦ Download an alternative, free program from the internet and compare this to yours.

# Managing and storing your pictures

Once you start taking pictures, you'll be surprised at how quickly your computer begins to fill up with these large picture files. If you've simply saved them into the 'My Documents' or 'My Pictures' folders already set up for you, you'll soon find it impossible to find particular images unless you group them in some way. The simplest method is to set up folders and sub-folders in which to store related pictures. This chapter explains how to do that. It also tells you about creating catalogues using photo management programs and about the options for long-term storage of your photos.

## Creating folders

To create a new folder:

1   Open the parent folder (in Windows machines this is already set up for you as 'My Pictures', but you can save picture files in any folder).
2   Go to 'File – New' and click 'Folder'. A new folder will appear in the window. Type a name over the highlighted text.
3   Click the mouse or press 'Enter' to complete the process.

Keep subdividing the folders into sub-folders so that related photos can be stored together in small groups. For every category, open the folder and go to 'File – New' to make a sub-folder inside.

You can make as many
folders as you like –
naming them clearly will
remind you of the contents

In Windows XP machines, you can also use the Tasks pane and select the
'Make a new folder' option.

Using the Tasks
pane

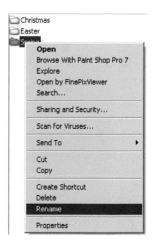

If you change your mind about the name you
have given a folder, right-click and select
'Rename' from the menu that will appear.

You can rename a folder at any
time – once the cursor is flashing,
just type over the old name

## Moving pictures into folders

Once you have organised your work space into folders and sub-folders, it
will be easy to save pictures into suitable locations each time you download
new ones from your camera. You may want to start, though, by
reorganising your current stock of pictures.

To move picture files into folders:

1    Open the folder containing the pictures you want to move.
2    If you want to select a range of files, click the first with the mouse,
     then hold down 'Shift' as you click the last. All files in the selected
     range will be highlighted.

3   If you want to select a number of non-adjacent files, click the first and
    then hold 'Ctrl' as you click subsequent files.
4   Click the Tasks pane 'Move' option and select the new destination for
    the files in the window that opens.
5   Click the 'Move' button and they will be moved.

Moving a
picture file
using the
Tasks pane

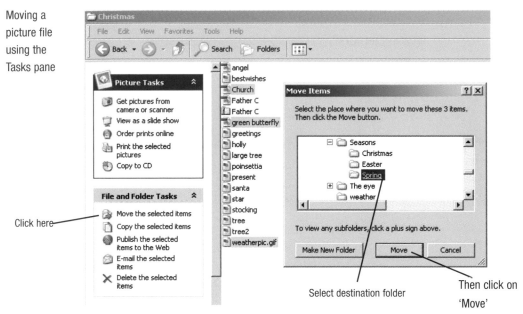

Click here

Select destination folder

Then click on
'Move'

As an alternative method:

1   Right-click a selected file and choose
    'Cut' from the menu.
2   Work through your folders until you
    find the correct destination folder.
3   Open it, select 'Paste' and the
    selected file will appear.

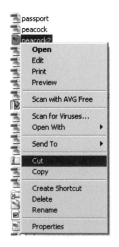

A third, and perhaps even easier, method is
to use *Windows Explorer*, a file
management system available on Windows
machines:

Moving a file
using 'Cut' and
'Paste'

1   Right-click the 'Start' menu and select 'Explorer' or click on the
    'Folders' button on the toolbar.
2   You will see all your computer folders in a list in the left-hand pane.
    Any folder containing sub-folders will show a + sign, so click this to
    expand the folders structure.

3   Click the folder containing the pictures you want to move so that the files are visible in the right-hand pane.

4   Locate the destination folder. If it is not visible on the screen, use the scroll bars to bring it into view.

5   Select all of the files you want to move in the right-hand pane.

6   Use your mouse to drag one across the dividing line towards the destination folder. All of the selected files will move together.

7   When the destination folder turns blue, let go of the mouse and the files will drop inside.

8   If you drag the files across with the *right* mouse button, you will be offered a menu from which you can select 'Move here', or 'Cancel' if you have highlighted the wrong folder.

Dragging files into a new folder using Windows Explorer

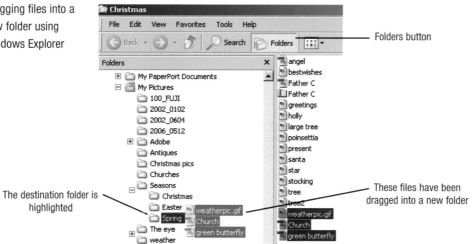

Folders button

The destination folder is highlighted

These files have been dragged into a new folder

## Finding a picture again

However well you may have filed your pictures, it's easy to lose them in a computer's vast filing system, especially if they weren't named carefully when saving. So it's useful to know quick methods to find them again.

### Arranging files

When any folder is open on screen, the 'View' menu or 'Views' button will allow you to display your files in different ways. You can change from a simple list of file names to thumbnails showing tiny versions of the pictures.

You can also click the 'Arrange Icons by' option on the 'View' menu and then select how the pictures are organised. This can be useful if you want to locate a particular photo and can only remember the date it was taken or its size, but nothing else about it. By reorganising the files in these ways, you might be able to spot the one you are looking for.

Arranging
your pictures
by name,
size or type

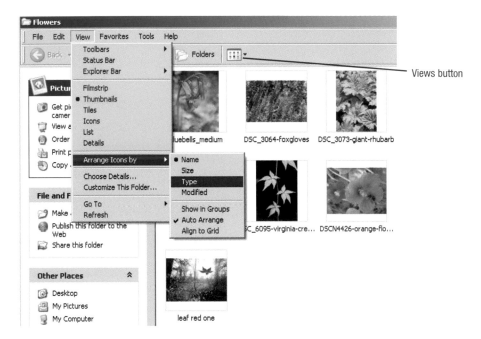

Views button

## Using 'Search'

To search for a file whose whereabouts is completely unknown:

1   Open the 'Start' menu and select 'Search', or click the 'Search' button on a folder's toolbar.
2   In the search pane, select 'Pictures' (if you have it) and then complete as many of the boxes as you can.
3   Enter all or part of the file name (you can use * for missing letters) into the name box. If you know it was saved as a JPEG or TIFF file, add the extension after a full stop (for example green butterfly. jpg for a JPEG file).

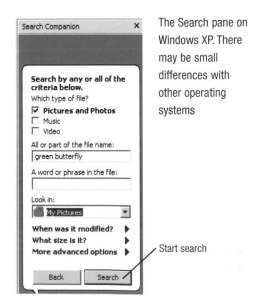

The Search pane on Windows XP. There may be small differences with other operating systems

Start search

Your picture has been found

4   You can drop down the list of locations in the *Look in*: box and click 'Browse' if you know the actual sub-folder in which the picture was stored.

5   Add other details if you have them, such as size or when it was modified.

6   Click the 'Search' button and the file should be located.

## Catalogues

If you want to be more organised about the storage and retrieval of your pictures, you can use a database application or a file management program that is specifically designed for photos. These programs enable you to assign keywords to photos to help in your searches. You can buy them on the internet or from shops, such as *PC World*. Some of the many examples include:

∗   *Picasa*
∗   *ACDSee*
∗   *Match*
∗   *Photoshop Album*.

### Programs for managing pictures

To show how useful it can be to use a dedicated management program, download *Adobe Photoshop Album Starter Edition* free from **www.adobe.com**. Select desktop for the installation program so you can find it easily once it's on your computer.

Downloading Adobe PhotoShop Album fron the internet

Once the program has been downloaded, double-click it to install the program fully on your computer.

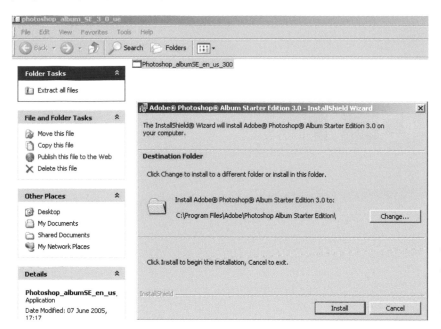

The next step is to install the downloaded program, otherwise you can't do anything with it

When you open it, you can select where to find the pictures you want to add to the catalogue. This might be directly from your camera or from within your computer. Once you've done this, every new photo you download onto your computer can be added to the catalogue very easily.

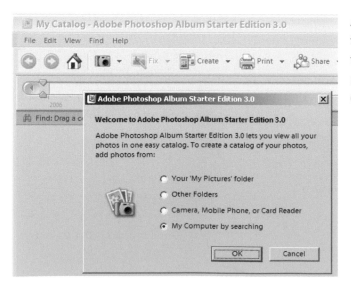

Adding pictures to the catalogue – in this case the pictures are already on the computer

If you select 'My Computer', the program will search all your folders and locate your pictures. A thumbnail of each picture will be displayed in the window during the search.

Thumbnails of the photos as they are added

At the end of the search, when all files larger than 100KB have been located, they will be displayed as thumbnails in the main window. You can reorder them according to date or the folder in which they are stored.

What you are seeing in the area known as the 'Photo Well' is a copy of each picture, so that you can locate them easily and carry out a range of tasks, such as printing, emailing or renaming from within *Photoshop Album.* If they were not properly filed, or had been stored along with text and other documents, it can be very useful to be able to view all of your pictures in one place.

To make use of *Photoshop Album*'s search facilities, click the 'Organise' button. As well as marking individual pictures to create new collections so that you can send them by email or display them in a slide show, you can also label them for quick searches. Click the 'Tags' tab and either use one of the ready-made category or sub-category labels or create your own by clicking the 'New' button and typing in a name. For example, open the 'People' category, click the 'Family' sub-category and then create a new

Copies of all your pictures in the 'Photo Well'

tag for each family member. The icon for any tags will be created the first time you click a picture, but for categories you must choose an icon from the list.

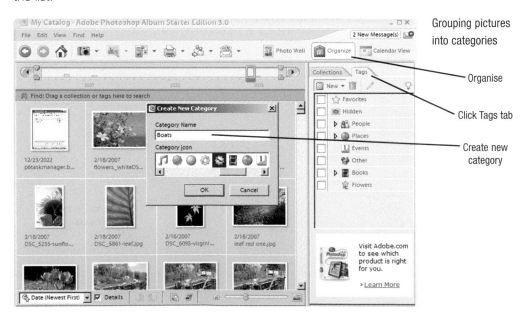

Grouping pictures into categories

Organise

Click Tags tab

Create new category

You can now look through all of your photos and drag one or more suitable tags onto any picture. They will display the chosen icon(s) next to their name. The greater number of different tags you add, the easier it will be to find appropriate pictures during different searches.

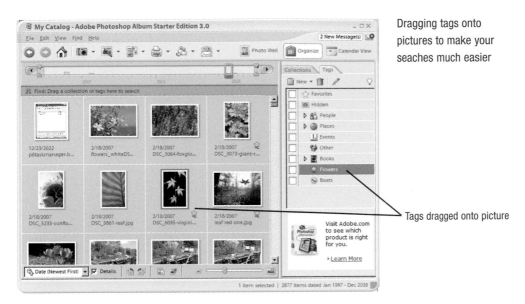

Dragging tags onto pictures to make your seaches much easier

Tags dragged onto picture

To find related pictures, click in the empty box next to one or more tag names in the list. A pair of binoculars will be displayed and all the tagged pictures will be shown in the left pane. Click 'Show All' to see all of your pictures again.

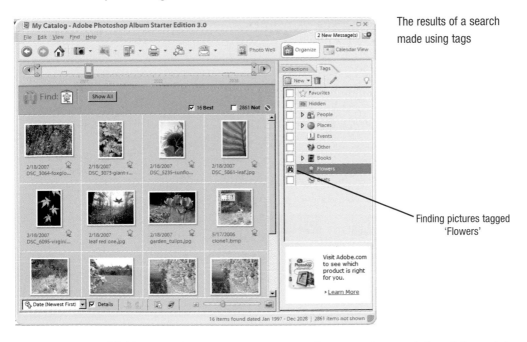

The results of a search made using tags

Finding pictures tagged 'Flowers'

Clicking the 'Calendar View' button allows you to search for pictures taken on a particular day. If more than one was taken, you can step through the pictures in the viewing window.

Viewing pictures taken on specific days using the 'Calendar View'

Viewing window

There are many other options in the program, including:

* Running a slide show of all your pictures or those in a collection
* Printing
* Adding a caption
* Renaming
* Emailing
* Sharing them online.

You will also find that there are links to commercial internet websites that will turn your selected pictures into greetings cards or calendars.

Other programs (such as *Picasa2,* which is available free from **http://picasa.google.com**) work in a slightly different way. You can right-click any picture and select 'New Label' to add a named tag, and then right-click subsequent pictures to add the same or a different label. You can also select a complete folder of pictures and add the same label to all of the pictures in one go. Labelled pictures are then easy to find at the top of the folders list.

Labelled collections

All picture files

Selected for labelling

Tagging pictures, this time using Picasa

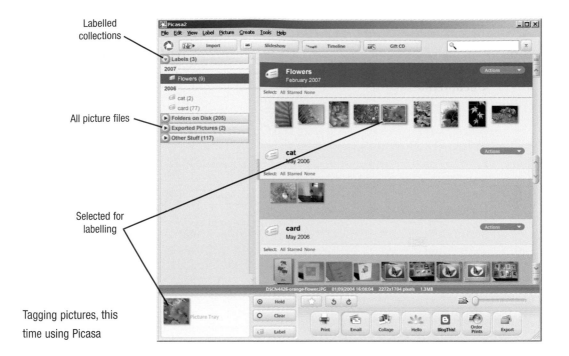

## Long-term storage

As computers can crash, you should always make backups of any precious pictures – perhaps on a CD. As picture files take up a great deal of space anyway, it's a very good idea to archive images onto some other device besides your computer for long-term storage. If you store the pictures in suitably named folders and label them carefully, small groups of pictures are quick and easy to search and find.

You could buy an extra hard drive, which you can then attach to any computer, but most people store their pictures on removable media, such as CDs and DVDs. As these are device independent, they can be viewed on any kind of computer and even on non-computer devices, such as televisions.

CDs are much cheaper but can only hold about 650MB of data, whereas DVDs can hold around 4GB of data per disk. To help identify the contents, you could produce an index print for a small number of photos (see Chapter 10 for more information), or list the directory hierarchy that is on the disk and keep this inside the plastic jewel case.

> If possible, store the digital images in a lossless format, such as TIFF or as the original JPEGs.

## Saving to CD

To be able to save onto a CD (and the same applies to DVDs), you will need a CD-writer, the appropriate disks and suitable software. If your computer does not have an integral writer, which is usually the E: drive, you can buy an external one that can be plugged in.

CD-writer

Windows XP machines will copy files onto CDs using a program already installed. You just need to select the 'Copy all items to CD' option from the 'Picture Tasks' pane.

Some photo management systems, such as *Picasa2,* have this option as well – you can even include music and create a slide show for your photos.

Copying onto CD using the Windows XP Tasks pane

Save pictures

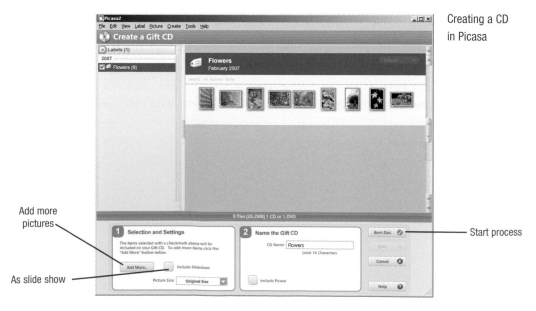

Creating a CD in Picasa

Add more pictures

Start process

As slide show

To take more control of the process and use software that will also create audio CDs, you may prefer to use an alternative program, such as:

* *Roxio's Easy Media Creator*
* *Nero's CD Burning Suite*
* *NTI CD Maker*
* *Pinnacle Instant CD*
* *Power2Go.*

You can find these and a wide range of other programs – usually available free – on the internet. To learn what else they offer, visit a comparison website (such as **http://cd-burning-software-review.toptenreviews.com**).

---

Although there are CD-RWs (rewriteable CDs) that allow you to write to them repeatedly, for picture storage it is best to use CD-Rs (recordable CDs) which are inexpensive and can be read on any machine.

---

If you want to edit or email a photo, open the original file from the disk, save it onto your computer and work on it there.

The technology used for recording on a CD is known as 'burning', because a laser alters the surface of the disk, creating a digital pattern that is then read when the disk is placed in your CD drive.

Modern CD-burning software works in a very user-friendly way, as the folders containing the photos you want to store can be dragged and dropped into place. The whole hierarchy of folder directories can be preserved so that the CDs are well organised when you use them later.

To burn a CD:

1 Open your program and click 'Make a data CD'.

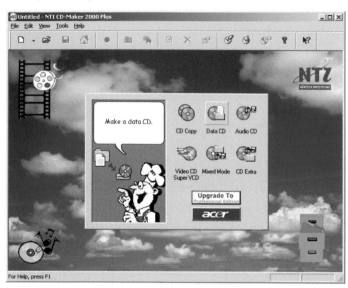

Creating a CD using
NTI-CD Maker

2 When the main window opens, use the *Windows Explorer* pane to
find the folders containing your pictures.

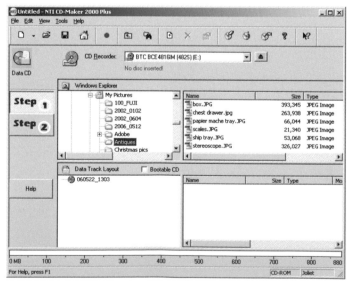

Locating the photos
you want to save
onto the CD

3   Drag complete folders, or open them and drag individual files, to the lower, layout pane. Folders will be displayed in both left and right panes.

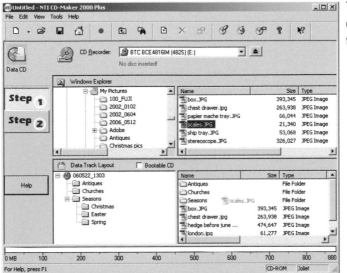

The highlighted file can be dragged to the lower pane

4   When all of your files have been selected, insert the CD into the CD-writer drive and click on Step 2.

Keep the settings that are offered and click 'Start'

5   It's usually best for beginners to accept the default speeds and other settings, so click 'Start' to begin the recording.

Your CD is ready – click 'OK'

You will see a progress window during recording. A message will appear to confirm when the process has been completed. Your CD will then be ejected automatically from the drive.

Some programs also offer you the option to design and print a jewel case CD insert and label.

Creating a label to insert into the jewel case with the CD

If you like the idea of adding extra special effects, use one of the free trial versions of DVD slideshow or DVD-burning software programs to create a show that you can save onto DVD.

You can get these from the internet. Examples include *Adobe Encore DVD, Photo Slide Show Maker* and *PhotoShow Express.* Some of the programs are free.

Software to help you create a DVD slide show

## Web space

The free web space provided by your Internet Service Provider is used to display a page that others can access, but it can also be used as a remote storage area. If you upload your pictures to this space but don't tell anyone the location, you can keep them there safely for as long as you want or until you change your ISP and need to move them. If during that time you lose your originals, you download them back to your computer (see chapter 13 for details). This is a handy way of keeping as much of your computer's memory free as possible.

You may also be able to use one of the free, or reasonably priced, online photo sharing services (see page 152) as a storage area for spare copies of your most important photos, although sometimes this is only for a limited time.

Storing your photos on a website

## At the end of this chapter you should be able to...

♦ Set up a series of folders and sub-folders in 'My Pictures' to store some of your own photos.

♦ Copy a number of image files across into a different folder.

♦ Use 'Search' on your computer to find a photo you have misplaced!

♦ Download a photo management program from the internet (such as *Adobe Photo Album* or *Picasa2*) and install it on your computer.

♦ Tag some of your photos and carry out a search to find a set of pictures quickly.

♦ Download a free CD-burning program from the internet (such as *CD-Burner XP Pro*, *FinalBurner*, *Pinnacle Instant CD* or *Media Monkey*) and practise selecting files to save. But don't waste a CD by actually burning them unless you really want to save them.

# Making simple changes

If you want to make some changes to your photos, it's very easy to use the tools provided by an image-editing program. Even the most basic software will offer you a range of useful functions. These allow you to take more control of your pictures: you can tidy them up by cropping the parts you don't like, or you can add some text to remind yourself where you were and when. They're simple and easy tasks to perform, and you won't look back once you've mastered the basics.

## Opening your image-editing program

Before you do any editing, you need to open the software. This can be done in three different ways:

* from your 'Programs' listing which you find via the 'Start' button;
* from an icon (if there is one on the desktop); or
* you can start with the actual picture file and open it from there.

If you have been viewing your photos on your computer desktop and want to work on one particular picture, double-click its name and it will open on screen. If it opens into the wrong program, close it again and then follow these instructions to make sure it opens into your chosen program:

1   Right-click the picture and select 'Open with...'
2   If the correct image-editing program is listed, click on its name. Otherwise, select 'Choose program'.

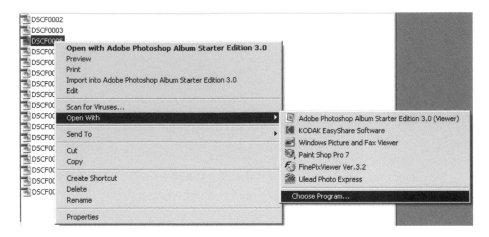

Selecting the right image-editing program to work with

3    You can now scroll down the list of programs on your computer to locate the one you want to use.

4    If you would like all your photos to open into this program in the future, click the box labelled 'Always use the selected program to open this kind of file'.

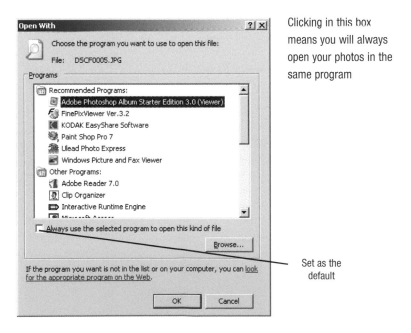

Clicking in this box means you will always open your photos in the same program

Set as the default

## Viewing your pictures

If you open your image-editing program first, it is easy to view any picture:

1   Go to the 'File' menu and select 'Open' or 'Get Photo'.
2   You can now search through the folders on your computer, including the CD or camera drives.
3   Select any file and preview it if this is offered.
4   Press 'Enter' or click 'Open' and it will open on screen.

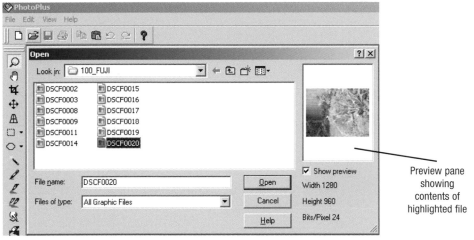

Preview pane showing contents of highlighted file

Selecting a picture to open

### Browsing

When you have a lot of photos on your camera's memory card or in a folder, you may want to look at them all at once. Some image-editing programs will enable you to do this by 'browsing'.

If your image-editing program has this function, select 'File – Browse' and click on the icon for the memory card or the relevant folder. Some programs, such as *PhotoShop,* have shortcuts to the browse option on the toolbar.

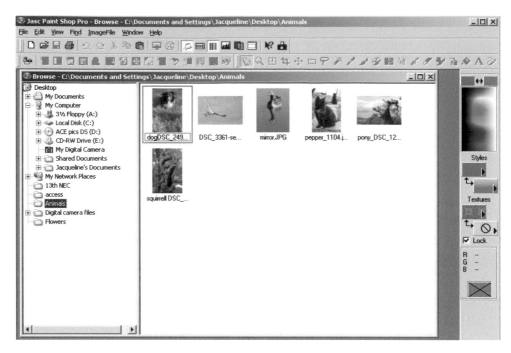

See all of your pictures at the same time with the 'Browse' option

Small thumbnails of all the pictures will be displayed. You may be able to change the view by selecting an alternative, such as large thumbnails or details, in the 'View' menu. Double-click any image to open it fully in its own window.

Changing the view from large to small thumbnails

## Viewing pictures still in the camera

With some software, you may be able to 'acquire' the images directly from the camera or from a scanner using TWAIN technology. (TWAIN is a universal public standard which allows you to use different software programs with camera and scanning equipment.)

First, connect your computer and camera using the cable supplied when you bought the camera.

To get your pictures, click on 'File', then 'Import', then 'Digital Camera' and then 'Configure' (in *Paint Shop Pro;* other programs may offer a 'Select Source' option) and make sure your camera or scanner is listed.

Accessing pictures directly from your camera

Now you can select 'Digital Camera', then 'Access' or 'TWAIN'. Then select 'Acquire' (or the equivalent menu option in your software) and your pictures will be downloaded directly.

You can also use the 'Picture Tasks' option in Windows XP machines to get pictures from your camera or scanner.

This will open a software program so that you will then be able to download the pictures from your camera.

# Saving images

As well as saving individual pictures in the normal way, your image-editing software may offer an automatic save on the 'File' menu or from an introductory menu when the program first opens. Use this if you want to make sure all of your pictures are saved from the camera straight away.

This function saves all your photos simultaneously and automatically, once you have 'acquired' them

In Windows machines, the pictures will be placed in a new sub-folder inside 'My Pictures', labelled with today's date.

Some programs also allow you to convert copies of your pictures to a chosen type of file, and output them to a particular destination in one go, through something called 'batch conversion'. This option will be available on the 'File' menu.

> If you are going to save JPEG files, perform as many edits as possible in one session so you are not saving to the format repeatedly and losing detail at each save.

# Rotate

Now you've opened and saved your pictures you can start to play around with them. The rotate option is one of the essential functions you need to know. It's used for pictures taken when the camera was held vertically, or if the image would look better rotated. There will be menu options to flip it, create a mirror image, or rotate it left or right by 90 degrees.

Use the quick rotate option to turn your picture round

In more advanced programs, such as *Paint Shop Pro,* you can also rotate your picture an exact amount. These options will be available from the 'Rotate' or 'Image' menu.

Type the angle in here to rotate an exact amount

## Crop

Many photos are spoilt because an unwanted person or object has found its way into the picture. Others would look better if less sky or water had been included.

With editing software, it is very easy to remove these extra parts of a picture using the 'Trim' or 'Crop' option:

1   First you have to draw round the part of the picture you want to retain, using a 'Selection' tool.

2   Click the 'Selection' tool button on the toolbar ⬚ and then use your mouse to draw the shape you want. A dotted line will appear showing the selected part.

Draw round the part of the picture you want to keep

3   Click the 'Crop' tool on the toolbar, or select an option, such as 'Crop to Selection'.

Click on 'Crop' to remove unwanted parts

You can often use a 'Crop' tool  directly – click to turn it on, draw round the part to retain and double-click inside the selected area to remove any unwanted parts of the picture.

## Adding text

It may be helpful to add a title or other text on your picture for future reference, or when using the image in a publication. It can also be fun to add text to a picture and email it as an electronic postcard.

To add text to a picture:

1   Find the 'Text' tool (it will be shown as a T or an A) and click on it to turn it on. You may then need to click on the picture.
2   A 'Text Entry' dialogue box will open.
3   Type the text you want first.
4   Then apply your preferred formatting – for example you may choose bold Sans Serif font size 18 in red.
5   When you are happy with it, click 'OK'.

When adding words to pictures you can format the text in the usual way

When the text appears, it will be in editing mode so that you can move it into position by clicking on it (and holding down) and dragging it into position. If you want to return to the dialogue box all you have to do is double-click on it, and you can carry on making changes to the formatting.

With some programs you may need to select a 'Move' tool before you will be able to drag it around.

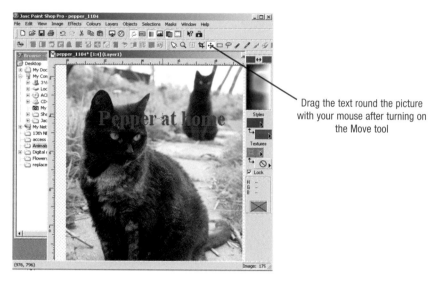

Drag the text round the picture with your mouse after turning on the Move tool

More advanced programs will have other options, including stretching or rotating the text. In these programs, extra items (such as text) are added on their own layer, which makes it easy to work on them separately later.

They will also allow you to create textured text by filling the centre of each letter with a choice of patterns.

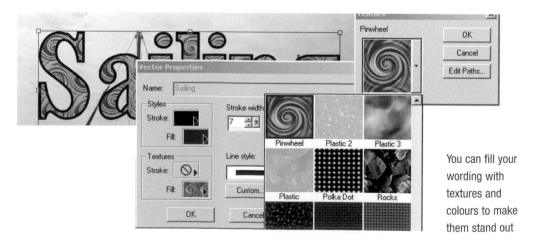

You can fill your wording with textures and colours to make them stand out

# Changing the size of your pictures

The size of a digital image can be changed depending on what you eventually plan to do with the picture. When resizing your picture it helps to understand about resolution or pixels per inch (ppi). Once you've taken your picture, the total number of pixels – or small dots of colour – in your photo will not change; however, when you resize, you adjust the number of pixels *per inch* in your photo. It keeps the same amount of data – total pixel count – but spread over a wider or smaller surface. In other words, you are scaling the image up or down.

If you reduce the size of the image, the pixels move closer together. If you enlarge the image, the pixels spread out to fill in the expanded image area.

What you'll probably notice is that if you blow a smallish picture up quite a lot the quality won't be so good, because you've got less digital information over a larger area.

As a guideline, 72ppi is acceptable for computer use; 170–240ppi is good enough for general printing; and 300ppi might be needed for a book or magazine picture.

Change the size by selecting the 'Image size' or 'Resize' option from the 'Image' menu.

You can change an image's resolution by adding or subtracting pixels while keeping to the same dimensions. This is known as 'resampling' and would, for example, be useful if you wanted to increase the quality of a low ppi photo you had enlarged. Bear in mind, though, that increasing the number of pixels ('interpolating') does not usually produce a higher quality image, as image-editors need to create new pixels by making a 'best guess' as to their brightness, colour and saturation. Adding pixels can therefore sometimes make the image blurry or out of focus.

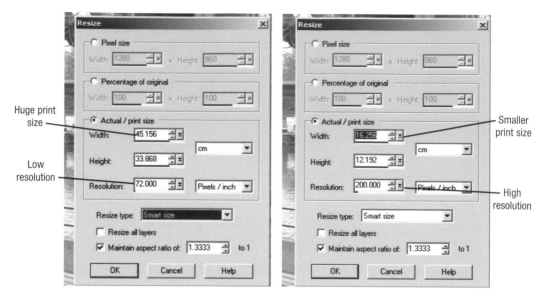

Huge print size — Low resolution

Smaller print size — High resolution

The left hand selection will result in a much worse image

So if you want a large print of a digital camera picture, always take it at the highest resolution offered by your camera.

Reducing resolution will mean that detail is lost and so you will not be able to print such a large picture. However, if you only want to view the picture online or send it by email, reducing resolution will reduce file size and make it quicker to send or download.

Some programs, such as *Photo Express,* have a useful set of standard measures that you can select from.

An easy way to select your picture size

You need to adjust the various settings carefully to produce the most appropriate size and quality of finished picture needed.

> It's a good idea to use the 'Save as' option when you have finished editing a picture. That way you can always go back to the original an start again if you want to.

# Printing your pictures

The simplest way to print your photos from your computer is to open the 'Print' dialogue box from the 'File' menu and set the number of copies and paper size for your photo before it is printed.

Decide if you want colour or black & white and make sure the appropriate paper type is selected.

If your printer does not have a black & white setting, select greyscale. (See Chapter 10 for more help with printing.)

## At the end of this chapter you should be able to...

♦ Open any picture into an image-editing program.

♦ Rotate it clockwise and then anticlockwise.

♦ Crop it so that you remove one unwanted part.

♦ Add some text that describes the contents.

♦ Save it with a new name into a suitable folder on your computer.

# Advanced editing

Now that you're confident about making some basic changes to your photos, you can look at being more adventurous. Many people get great satisfaction from altering their original photos – sometimes just to improve them, but often to turn them into works of art in their own right. For this, you will need a more sophisticated image-editing program than the ones that are usually supplied with digital cameras. Mid-price and advanced image-editing programs offer a very wide range of tools to use with your pictures. This chapter will take you through some of the options that will be available to you to help make your photos look fantastic.

## Toolbars

Don't be daunted by the number of different tools at your disposal, as they are fairly straightforward and are similar across a wide range of programs. In most, resting your mouse over the tool will display a 'screen tip'.

Move your mouse over the buttons and a 'Screen tip' will tell you what each one is for

Sometimes there will be an instruction along the bottom of the screen when you click a button, or there may even be fuller helpful hints to explain exactly what each one can do.

Some programs offer
lots of useful guidance

Making a
selection from
a drop down
menu

Toolbars can take up quite a bit of room, so they can't all stay open all the time. You will need to locate the toolbar or tab you want to use. For example, you may want to try different brush tip styles or change the shape of a selection tool. You can find these options from the menu, via a toolbar shortcut or by right-clicking on the screen. Close them when they are no longer needed so that they don't clutter up the screen.

## Undo

For any changes you wish you hadn't made, you can:

✱  hold down 'Ctrl' and press 'Z' at the same time;
✱  find the 'Undo' option on the 'Edit' menu; or
✱  click the 'Undo' button that always shows a left-facing curved arrow ↶.

Some programs have a 'history' option to help you return to earlier edits.

# Zoom

It is quite likely that you'll want to make changes to just a small part of a picture. To see details more clearly, zoom in or out by selecting the option from the 'View' menu, or by clicking a zoom in/out tool 🔍 .

Sometimes you must left-click to zoom in and right-click to zoom out, or use the + and – keys on the keyboard.

# Selection

You can use one of the 'Selection' 🔲 (also known as 'Marquee') tools to draw round part of your picture.

First pick the correct tool (below) and then change its detailed properties from the 'Options' window.

Simple selection ———————————— Freehand lasso

The rectangle (which can be changed to another geometric shape) is for simple selections and the lasso will allow you to draw freehand round a complex shape.

For awkward shapes, draw round them using the lasso

Choosing different
methods of 'Selection'

You can also set different selection methods, such as 'Point to Point' (which lets you click on the image at intervals round the edge and then joins these points up for you) or a smart selection that will lock onto complicated borders.

The 'Magic Wand' is a special type of selection tool which selects all parts of the image that have similarly coloured pixels. So it can be useful for selecting non-adjacent and awkward shapes.

Magic
Wand tool

The Magic Wand tool will select all parts of the picture that have the same colours

You can also use the wand to select an area you *don't* want. For example, in a photo of an outside landscape taken through a window, it may be easier to select the window frames and then choose 'Invert' from the 'Selections' menu to display the area you want to work with.

If you want to take off a selection:

✱ choose this option from the 'Selections' menu;
✱ double-click the image away from the selected object; or
✱ hold down 'Ctrl' and press the letter 'D' at the same time.

## Automatic settings

Some effects and repairs can be carried out using automatic settings or by applying an overall 'Quick Fix' or 'Auto Enhance' setting. But you will also be able to change different aspects of your photos manually.

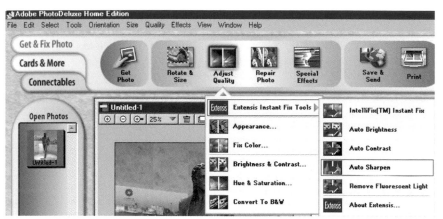

In this program there are a number of quick fix options for changing your photo quickly and easily

## Brightness and contrast

Increasing contrast in pictures makes the dark pixels darker and the light pixels lighter. For pictures with too many grey tones, you may want to increase contrast and introduce some highlights and shadows. On the other hand, a subject that has a single bright detail can skew the rest of the picture and make it too dark – in this case, the contrast would need to be reduced.

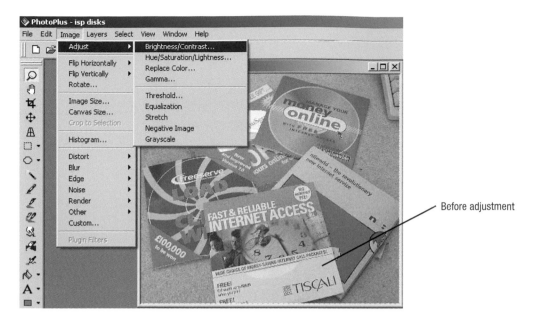

Before adjustment

If there isn't enough contrast, play around with the settings and see what happens to your picture until you find the effect you're happy with

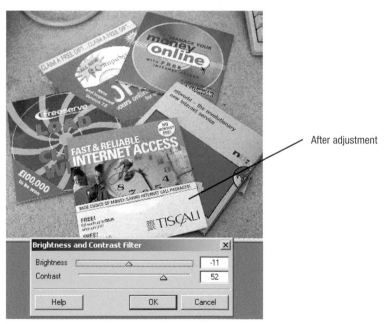

After adjustment

Most programs have automatic settings available from the 'Image – Adjust' or 'Effects' menu that you can apply to alter the picture quickly. You will either be able to drag sliders along or click an option, showing in a preview pane, to apply the effect.

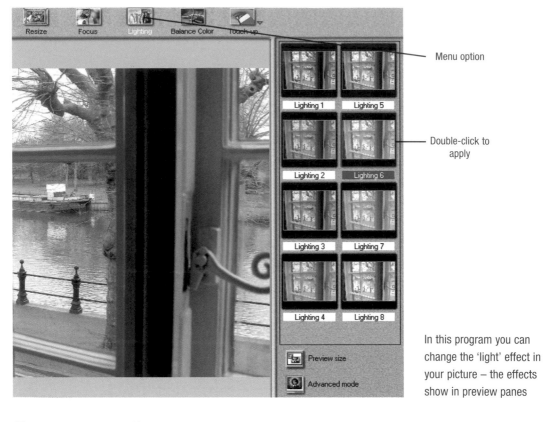

Menu option

Double-click to apply

In this program you can change the 'light' effect in your picture – the effects show in preview panes

# Gamma correction

If you took a photo in bright light and there is not enough detail in the picture, you can correct this to some extent using the 'Gamma Correction' option.

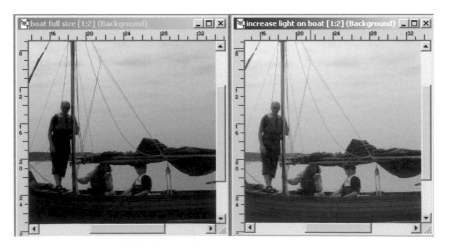

You can improve the clarity of a picture with Gamma Correction

As you do this, you can see how changes are affecting the photo by studying the 'Histogram' – this will be available from one of the menus. The Histogram is a measure of the brightness of the picture and shows the distribution of pixels in each brightness level. In many programs it is known as the 'Levels command' and you may be able to increase or decrease dark, mid and light tones separately for a more controlled improvement to the picture.

For overexposed pictures, you will see that there are very few mid or dark tones: the peak of the tone scale in the view below is to the far right with a mean of 231.

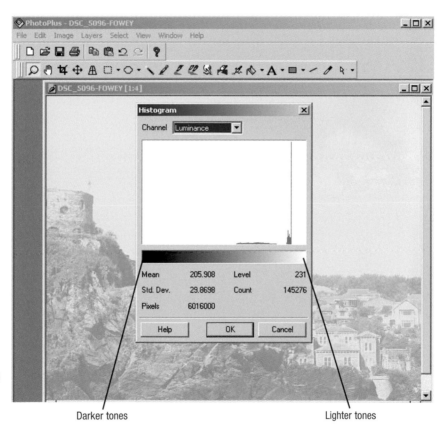

An over-exposed picture looks washed out – the Histogram shows no darker tones at all

Darker tones                                      Lighter tones

Reducing the 'Gamma Correction Filter' levels adjusts the mid tones and colour balance together to add missing detail.

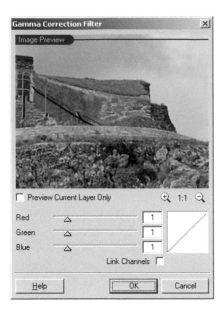

Gamma Correction can sharpen up the colour and mid tones

The detail on the image is now much clearer. The histogram shows more mid and dark tones.

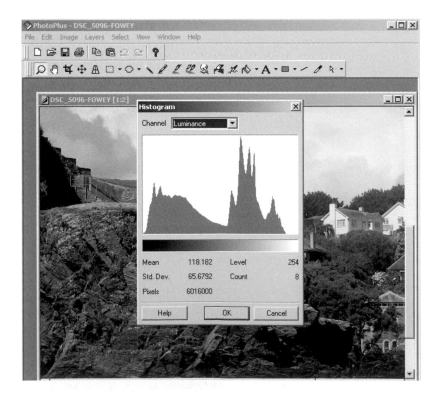

This new Histogram shows a better balance of dark, mid and light tones and the photo is much improved

Histograms can also be used to display the different RGB channels of an image.

# Red-eye removal

We saw in Chapter 4 how to use a flash setting on your camera to minimise the red-eye effect. But you may still have some photos in which your subjects appear like demons with red eyes. If so, you can select the red-eye removal option – in *Paint Shop Pro,* this is available on the 'Effects – Enhance Photo' menu.

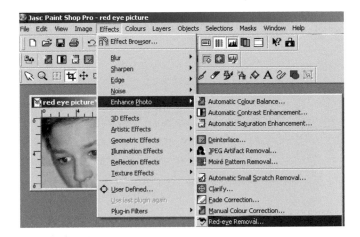

Find the Red-Eye removal option on the menu

If you start to use the setting and find that the wrong part of your picture shows in the preview pane, use your mouse in either box to drag the picture into a better position. The pointer will change to a hand. You can also zoom in closer using the tools available.

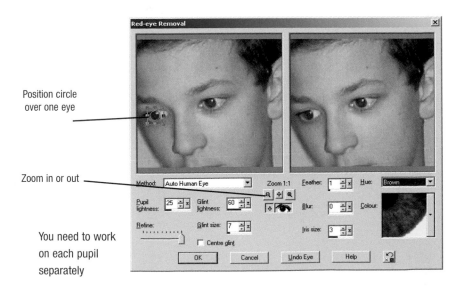

Position circle over one eye

Zoom in or out

You need to work on each pupil separately

Use your mouse to draw out a circle that you can position over the first eye. Increase or decrease the diameter of the circle and move the box so that it is positioned exactly over the iris.

Set the colour in the 'Hue' box – for example to blue, brown or grey. Add a 'glint' if you want some reflection, and feather the edges if they are too sharp. Check the result in the right-hand preview pane and click 'OK' when both eyes have been corrected.

## Colour

Many photos have to be taken indoors or in artificial light, and the colour of individual objects or the whole scene may take on a washed out or unpleasant tinge that you might want to adjust. You can also colour your photos sepia for a special effect or to look old, or change from colour to greyscale for a 'black & white' print.

If your computer monitor doesn't display accurate colour, it's difficult to work with your pictures. So adjust your monitor by eye to get good brightness and contrast. (You *can* calibrate it even more accurately, though – you may be able to change the properties of your monitor via the control panel or from within the graphics card software).

It's easy to alter colours with image-editing programs – either by applying an automatic setting or by fine tuning the colours yourself. Select an object or simply open the 'Colours' menu and apply the changes to the whole picture using the 'Colour Balance' options.

Using the menu to adjust a picture's colour balance

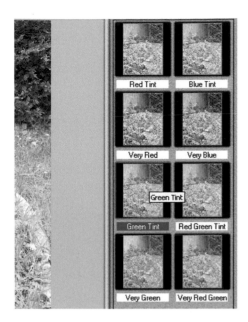

This preview display helps you choose just the right shade of green

Some programs offer a range of different effects in a panel, which makes it easy to compare and select the best option.

To make detailed changes, increase or decrease one aspect:

* 'Hue' moves the colours between the orange and blue ends of the spectrum, so you can cool down or warm up an image by changing the setting.
* 'Saturation' sets the density of the colour. A highly saturated hue has a vivid, intense colour, while a less saturated hue appears more muted. Totally unsaturated results in a grey picture.
* 'Lightness' sets how dark or light the whole picture becomes.

If you click on the eye symbol, you can preview the change in the whole picture.

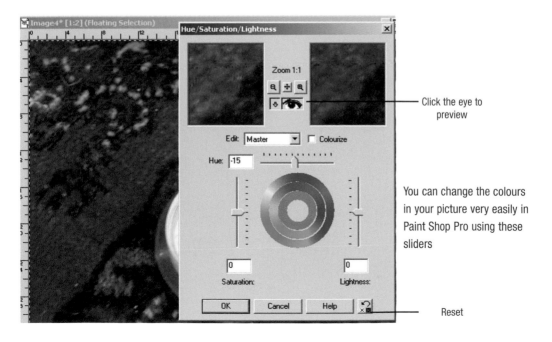

Click the eye to preview

You can change the colours in your picture very easily in Paint Shop Pro using these sliders

Reset

## Colouring by hand

If you are introducing colour into a picture, you can select from palettes of colours. Usually, a left-click in the panel will set the foreground (applied using the left mouse button to paint or spray on the picture) and a right-click will set the background colour (applied using a right-click). Double-click a box to open a wider range of colours.

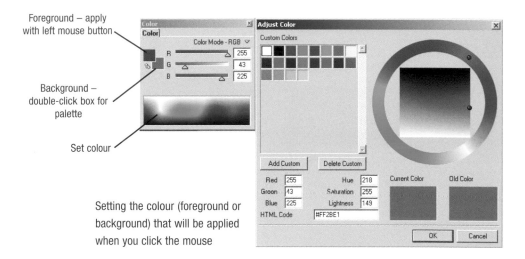

Foreground – apply with left mouse button

Background – double-click box for palette

Set colour

Setting the colour (foreground or background) that will be applied when you click the mouse

You can achieve a more natural effect if you use a colour which is already present in the picture. Use the 'Colour Pickup' or 'Dropper' tool first to pick up the colour from the picture.

To add more red to the left-hand spot on the butterfly wing in the picture shown, for example, what you would need to do is:

1  Click on the 'Dropper' tool and then click an example of the red colour.

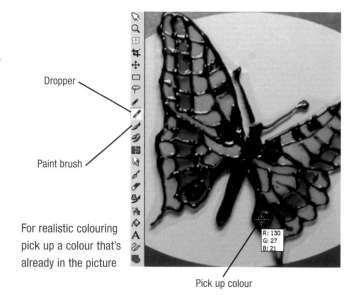

Dropper

Paint brush

For realistic colouring pick up a colour that's already in the picture

Pick up colour

Foreground colour

Styles

2. This adds the colour to the palette as the foreground colour (applied whenever you click the left mouse button).
3. Now you can select a brush, set the tip size and paint over the object you want to colour.

Depending on the program, selected colours can be applied using one of many painting tools – such as a paintbrush, flood fill or airbrush. Edges can be softened using a sponge, retouch or smudge tool.

Recoloured spot on wing

You can decide how to apply your new colour by selecting the appropriate Tool options

## Sharpen or blur

You may want to sharpen an image if it doesn't show enough detail. Sharpening adds contrast and crispness along the edges of objects or enhances differences between pixels of different colours. Bear in mind, though, that it can be easily overused and cannot compensate for a picture that is out of focus.

Depending on the program, you can find this option on the 'Image', 'Filter' or 'Effects' menu. If you select 'Unsharp Mask' there is a manual setting available where you can adjust the intensity visually.

Different sharpening
options on the menu

Original                    Sharpened to improve the picture                    Over-sharpened

'Blurring' the image, on the other hand, may be useful if too many details
(such as the names in advertisements) are visible. It can also be quite
effective, for example, to 'border' wording in a natural way, as the border
area will have the same tones as the rest of the image.

A blurred border is unintrusive, using colours already in the picture

# Scratch removal

Most programs have a quick fix for small marks on pictures. This is particularly useful when scanning old photos or if there was dust on the lens. Look to see if there is a simple tool like a brush 🖊. You should be able to change settings, such as brush size, before using your mouse to run the cursor over the marks.

Rub out scratches with tool

Scratch

If the automatic settings don't work well enough, select the target area and then carry out fine tuning by dragging the sliders until the marks are reduced or have disappeared altogether.

For some marks you need to change the settings more precisely using the sliders

## Cloning

A more sophisticated method for blending small marks into the background, to fill in gaps or remove unwanted objects altogether, is offered by the 'Clone' tool 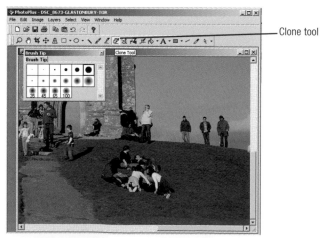 . Sometimes called the 'Rubber Stamp', it works by copying part of the picture. This copied part is then superimposed somewhere else to hide what is underneath.

You can pick up part of your image – such as the sky, grass or snow – with the 'Clone' tool and then cover up the unwanted parts by gently rubbing over the target area using the pointer like a brush. If you keep picking up new areas close by, so that you blend in slight changes in colour and tone, you can produce very convincing final results.

For example, here are the steps to take to remove a few unfortunate people from a picture:

1   Click the 'Clone' tool and then hold 'Shift' as you click on some sky in the picture, to pick up the colour and shape. (In some packages, you must right-click or use the 'Alt' key to select the area.)
2   Select an appropriate brush tip from the toolbar (usually available from the 'View' menu or by right-clicking the mouse on the screen).
3   Start 'painting' with the pointer brush. Blue sky should start to

Clone tool

Choosing the type of brush tip to use when removing something from your photo

appear. Pick up further sky and cloud around the unwanted area to blend in the superimposed parts as naturally as possible.

4    Depending on how much time you take on this, your finished picture can look completely natural.

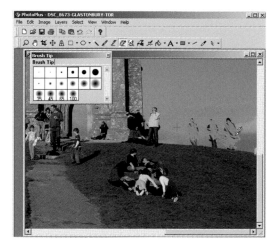

People
disappearing
under blue sky

## Borders

With most image-editing programs you can add a simple border round your picture. There may be picture frame options too. If you select the 'Picture Frame' option (from the 'Image' menu in *Paint Shop Pro*) and start the wizard you can choose from a range of oval or rectangular mounts as well as coloured and textured frames.

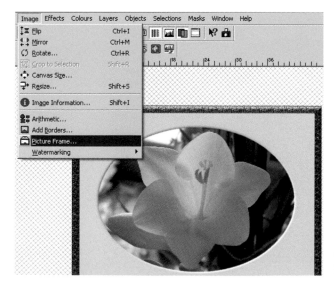

Add a 'virtual' frame to
your favourite pictures

## Special effects

To change a boring photo into a work of art, you can apply one of a huge range of 'filters'. Filters alter each pixel's colour, based on its current colour and the colours of any adjacent pixels. The results can vary from a minor adjustment of a single characteristic to a total alteration of an image. Some programs, such as *Paint Shop Pro,* allow you to preview all of the effects if you are not sure what changes they will make which makes it easy – and fun – to experiment.

Apply a page curl for an unusual effect

Filters tend to fall into different main groups. For example:

✳ You can distort the image with twirls, waves or ripples

The twirl turns your photo into a work of Modern art!

✳ You can simulate different artistic effects, such as charcoal, watercolour, oils or pencil

You can create a pencil drawing from a photo

✳ For an 'aged' look, you can apply a sepia or old newspaper filter

A modern photo looks much older at first glance

✳ You can include dramatic lighting, positioning lights in various places to highlight one or more parts of the image.

Create startling
effects by adding
a few spotlights

# Combining several pictures

Sometimes a photo would look better if part of another one is added to it,
or you might like to combine several into a photo-montage. In the more
advanced image-editing programs, each object added to a picture is placed
on its own 'layer'. You can work on any layer or arrange layers individually.
When the picture is finally as you want it, saving in a format, such as JPEG,
will combine all the layers into one. You can also save with a software-
specific file type to preserve the layers for future editing.

To combine some of your images in a
photo-montage:

1   Open both or all of the pictures in
    your editing program.
2   If you want to create a new
    blank canvas for your picture,
    start a new image by clicking the
    'New' button and set a
    background colour and size.

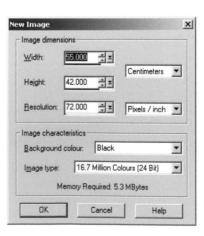

Choosing a size
and colour for the
background

3   It may help to view all open pictures at the same time (for example by selecting 'Tile' from the 'Window' menu).

4   Click on the first picture and draw round the object or area you want to use. For the best selection of awkwardly shaped objects, zoom in before using the lasso/freehand selection tool.

5   In some programs, you can drag the outlined object straight onto your canvas. Otherwise, press the 'Copy' button or go to the 'Edit' menu and then 'Copy' to place the object in the clipboard.

6   Activate the picture that will be receiving the object (by clicking its title bar) and select an option (for example in *Paint Shop Pro* it will be 'Edit – Paste – As New Layer').

Add all the pictures you are going to include in your montage

Pictures have been copied across

7   Continue copying and pasting until all of the sections are in place.

8   For any object other than the most current, you need to 'activate' its layer so that you can make changes, such as moving or resizing it. Click the 'Layer Palette' and rest your mouse on any layer to reveal which object it relates to. Right-click or double-click a layer and rename it to help identify the different objects.

Open Layer
Palette

Select the lay[e]
you want to w[ork]
on and use th[e]
Deformation t[ool]
(on the left) to
change its siz[e]

Deformation/
Transform tool

9   Click a layer in the palette to activate it and then click the
    'Deformation' tool (as shown above). This will allow you to
    drag out the boundaries to resize the object, rotate it or move
    it to another position. You can also move objects on an active
    layer after clicking the 'Move' tool .

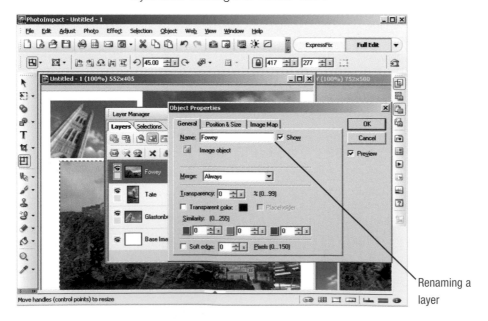

Renaming a
layer

10  If one of the objects needs to be above or below another, open
    the 'Layers' menu or right click, click 'Arrange' and select an option.

11 Arrange all of the elements, add text and anything else you like to create the finished picture. Save it.

The finished montage – it will need saving

> When continually changing things round as you use cut-out parts of one picture added to another, reorder the layers quickly by dragging the layer in the palette up or down using the mouse.

For unusual effects you can also make one layer more transparent by changing the measure or (in Paint Shop Pro) clicking off the red cross on the padlock and setting a new measurement.

Unlock transparency and set measure

Drag layer above or below another

Create a fantasy picture by making the top layer (the butterfly) more transparent

## Using the Eraser tool

Instead of using a selection tool to cut round one object before adding it to another picture, you can make use of the layers in the program in a different way. You can paste one whole picture over another and then 'rub out' parts of the top layer to reveal what is underneath:

1   Open both pictures.
2   Copy the picture to go on top (for example the commuters on a platform), and paste it as a new layer onto the background (the sea scene).

Add one picture to another by pasting 'As new layer'

3   Now click the 'Eraser' tool and rub out any part of the top picture you don't want. It will reveal the window scene underneath.

Use Eraser to reveal the layer below

When you've finished erasing the section of top picture you don't want, the one underneath shows through – with interesting results

## At the end of this chapter you should be able to...

◆ Adjust the colour balance to 'warm up' or 'cool down' the picture.

◆ Apply an artistic filter so that it looks as if the picture has been painted or sketched.

◆ Use the 'Clone' tool or 'Rubber Stamp' to remove an unwanted item.

◆ Open two pictures and combine them in some way, perhaps as a photo-montage.

Once you have mastered the basics, you will find tutorials on a wide range of image-editing software programs on the internet. Just enter your named software and 'tutorial' or 'tips' into a search engine and either download them or follow the advice online.

# Printing

There are three different ways you could print out your photos: use your own printer; send the pictures off to a photographic company, such as those advertising on the internet; or take them in to a high street retailer – perhaps using one of their self-help kiosks – as described in Chapter 3. Whichever method you use, you will want to prepare your images carefully for printing. This chapter looks in detail at how to get good results every time.

## Resolution

When printing out on photographic paper, the quality of your photos needs to be much higher than if you are displaying them on a computer monitor.

Although images in an image-editing program have a resolution shown in pixels per inch (ppi), in printers, this is referred to as dots per inch (dpi). The 'dpi' actually measures the smallest size of 'printer' dots and is the final limit to the quality of the printer.

The higher the resolution of your camera, the larger you can print an image. For example, a print with 150 dots per inch (150 dpi) can be produced in the following sizes, depending on the camera's resolution:

* 0.3 megapixels (640 × 480) can produce a 4" × 3" print
  (as 150 × 4 = 600 and 150 × 3 = 450)
* 1.2 megapixels (1280 × 960) can produce a 7" × 5" print
* 2 megapixels (1600 × 1200) can produce a 10" × 8" print
* 3.2 megapixels (2048 × 1536) can produce a 13.5" × 10" print
* 4 megapixels (2288 × 1712) can produce a 15" × 11" print
* 5 megapixels (2500 × 2000) can produce a 17" × 13" print.

The *same* picture printed at larger sizes will show a progressive decrease in the quality of the image.

Digital files for printing should have the equivalent of 150 to 300 pixels for every inch (150–300ppi). The most common setting that image-editing programs will automatically use is 72ppi, which will not have nearly the same high clarity that a 200ppi image would have.

You won't need to print at over 300 ppi – images beyond 300ppi are unnecessarily large for storage purposes. For inkjet prints 200ppi is usually enough.

## Types of printer

For high-quality, detailed colour photos, most people at home use a form of inkjet printer that sprays coloured dots onto the paper using a mix of coloured inks. Colour laser printers don't give results as good as those from inkjet printers, particularly inkjet printers designed specifically for photos.

Digital cameras, scanners and monitors use a combination of red, green and blue light to create all the colours in the spectrum (RGB colour). Most printers use a mix of cyan, magenta, yellow and black (CMYK) and lay down dots in patterns – the more white space between the dots, the paler the tones. Some printers also mix in pale cyan and pale magenta to reduce any graininess.

When looking at photo printers, you will see that they can use a range of different technologies. The most common are:

* Thermal – the print head is positioned near a heating element and as the ink is heated it expands and is forced through nozzles onto the paper
* Micro piezo – mechanical vibration is used to fire the ink droplets onto the paper
* Dye sublimation – the print head heats a dye ribbon which creates a gas that hardens onto the paper.

Many models have a memory card reader which allows you to print photos without turning on your computer, but for maximum control you will need to connect your printer to a computer and print directly from the desktop or image-editing program. Some printers combine scanning, copying and printing, or you could buy a printer dedicated to printing photos. You may even find a printer that is network ready – this means that if you use a shared broadband connection for all of the computers in your house, they could access the printer as well.

Updated surveys of printers can be found on the internet or in magazines such as *ComputerActive.* They regularly analyse and compare the cost of producing prints of different quality and size using cheap, middle-range and expensive models.

If you are not expecting to create professional quality prints to sell, you will probably find that a printer costing around £80 to £100 produces excellent results. Think about your priorities before buying a new printer and decide whether noise, size of output, speed or print versatility are important factors for you.

Hewlett Packard Photosmart 385 InkJet Printer
★ ★ ★ ★ ★ Read 2 reviews
Digital Photo, Color Printer, Thermal Inkjet Printer, Color Resolution: 4800 x 1200 dpi, Black Resolution: 1200 x 1200 dpi, Instal... Read more

**£80 - £150**
from 16 stores

Compare Prices

Save it

Canon SELPHY CP710 Thermal Photo Printer
★ ★ ★ ★ ↑ Read 4 reviews
Digital Photo, Color Printer, Dye Sublimation Printer, Color Resolution: 300 x 300 dpi Read more

**£80 - £149**
from 16 stores

Compare Prices

Save it

Samsung SPP-2040 Thermal Photo Printer
★ ★ ★ ★ ★ Read 2 reviews
Digital Photo, Color Printer, Thermal Transfer Printer, Black Resolution: 300 x 300 dpi, Speed: 60 sec/page, Installed RAM: 32 MB,... Read more

**£77 - £126**
from 13 stores

Compare Prices

Save it

Epson PictureMate 500 InkJet Photo Printer
★ ★ ★ ★ ☆ Read 1 review
Digital Photo, Color Printer, Micro Piezo Printer, Color Resolution: 5760 x 1440 dpi, Black Resolution: 5760 x 1440 dpi, Speed: 77... Read more

**£90 - £149**
from 18 stores

Compare Prices

Save it

Use a comparison site on the internet to find reasonably-priced printers

What may appear to be a bargain printer could turn out to be expensive in the long run if you have to buy costly all-in-one ink cartridges. It may be much cheaper to use a printer where you can replace coloured inks individually and for which there are inexpensive 'own brand', compatible or remanufactured cartridges available. So check the cost of the cartridges before you buy.

## PictBridge

You may see the term 'PictBridge enabled' in advertisements for the latest digital cameras and photo printers. PictBridge is a facility that allows you to connect your camera directly to a printer via a PictBridge USB cable. This means you do not need to turn on your computer or insert a memory card for printing. Not all printers and cameras support this function, so check to see if your equipment is compatible. Most cameras come with some sort of USB cable to allow you to connect your camera to a PC – but just because your camera comes with a cable doesn't mean that it is PictBridge enabled.

The main disadvantage with PictBridge, apart from compatibility, is that your camera needs to be switched on while it is connected to your printer. If you don't have a convenient power source available, then your camera could run out of battery power in the middle of a print run.

## Paper

There are different types and weights of paper you can use that give quite different results, depending on your requirements. As well as gloss or matt photo-quality paper cut to various sizes, you can use watercolour, cloth or stippled paper to give unusual results.

Buy proper photographic paper for the best results

Different types of paper are suitable for different types of printer, so take care when choosing paper. Photo paper can also be expensive.

According to most manufacturers, it is recommended that you use at least 230gsm heavy weight paper for good results. You use the glossy side for printing on and should take care not to handle the paper and leave greasy marks on the surface. Store the paper in its original packaging, away from extremes of temperature and humidity.

## Setting the printer options

When setting the printer options, you can select the type of paper and choose whether or not to produce a print with a white border. You can also print in greyscale (black & white).

Select to print with border

Paper type

Size of print

Choosing the type and size of paper and deciding whether to add borders

You may be able to use your printer's enhanced colour settings to make final adjustments before you print.

Preview pane

Take time to make last minute adjustments

When the photos have printed, you don't want to spoil them by smudging them. So resist the temptation to pick them up straight away – let the ink dry before handling them and don't stack them on top of one another.

## Contact sheets

Some packages will let you print a large number of photos as thumbnails on one page. A sheet like this can be very useful to keep with a CD containing a number of pictures, or to help you select photos that you might want to print later.

In some programs, such as *FinePixViewer,* this is called an 'index print'. Select the option from the 'File' menu and then decide how the pictures should be arranged and whether or not text should be added to the pages.

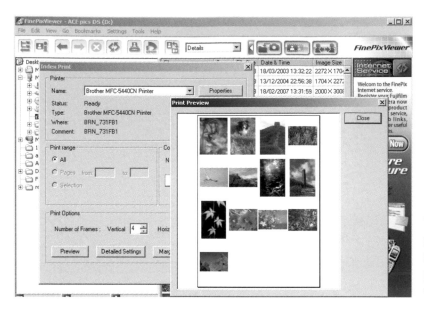

To display several photos as thumbnails on a page pick an 'index print'

Other programs offer a 'contact sheet'. One program that offers this is the *Windows Picture and Fax Viewer*, which is available on all Windows XP machines:

1   Right-click any picture on the desktop and select 'Open with' to open and display your photos in this program.
2   You can now click the print icon to start the wizard.
3   Select which pictures you want to include by clicking the boxes or selecting them all.

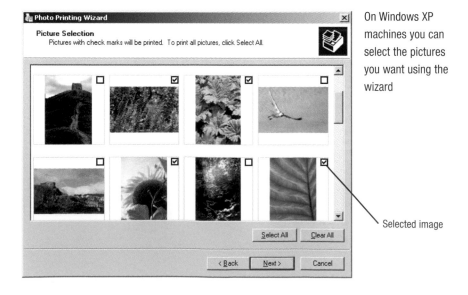

On Windows XP machines you can select the pictures you want using the wizard

Selected image

4   Now choose the correct printer and paper and then decide on the
    layout before printing.

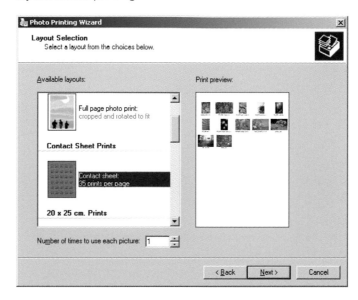

Check the print
preview, then
select 'contact
sheets'

Many photo-management programs also offer a contact sheet
print option. One example is *Photoshop Album,* which is
described in Chapter 7. The option is available in the 'Print'
dialogue box.

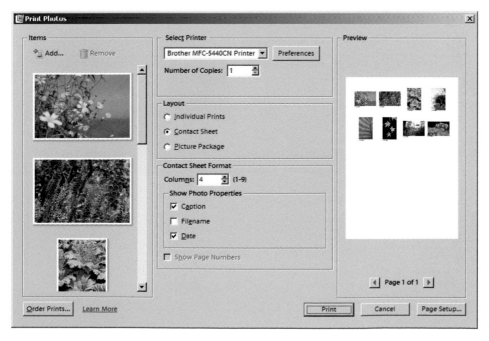

The 'contact
sheet' option
in Photoshop
Album

## Multiple images on a page

If you want to organise and display several differently sized photos on one page, some programs, such as *Paint Shop Pro,* have this option:

1  Open all of the pictures you want to print.
2  Click 'Multiple Image Printing' on the 'File' menu. This will display a blank page and the open pictures as thumbnails in their own pane.
3  Drag each picture onto the blank page.
4  If an error message is displayed saying it will not fit, click 'Yes' to resize it using the mouse.
5  Arrange by dragging them to where you want them or click the 'Auto Arrange' button. You can also set each one using the individual placement buttons, for example top left or bottom right.

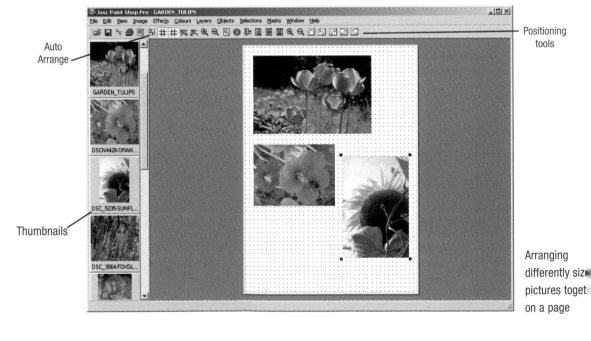

Auto Arrange

Thumbnails

Positioning tools

Arranging differently sized pictures together on a page

## Online print services

For very high-quality prints, if your own printer is not up to the job, you can now find hundreds of companies over the internet. These produce prints of different sizes – including poster size – for a very reasonable price, and the more prints you order the cheaper each one will be.

Online print companies can be very good value and are often quite quick

There is also an option in the 'Picture Tasks' pane in Windows XP machines to link to printing companies.

Click to start wizard

Once you start the wizard, you will be offered a choice of online print services.

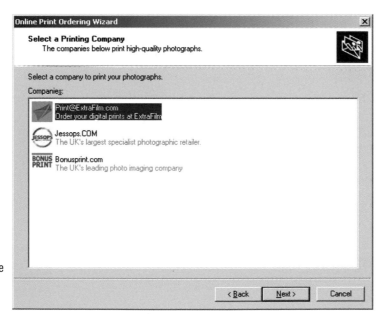

Choose one of the companies to print your photos

Having selected a company, follow the prompts to select sizes and products before registering your details. You may be asked to sign in with a username and password. For example you may be asked for a *Microsoft.NET Passport*, but it is easy to set up an account if you do not already have one.

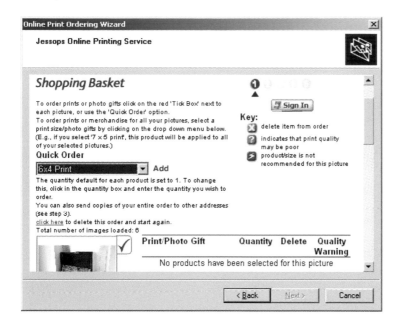

Register with the website and then order your prints

If you find a company yourself on the internet, they all work in a similar way – register your details on their website and then transfer the files from your computer using a link or software that they will provide.

You will now be able to select the type of print, numbers and size, that you want. Your photos will be posted to you in a matter of days. You can also use these sites to share your photos with friends around the world, or to buy gifts bearing your own photos, as described in Chapter 13.

## Iron-on transfers

It's actually quite easy to create your own personalised T-shirts if you buy iron-on inkjet paper and have a suitable printer. Although you could try with dark colours, it is likely that the best pictures will be produced if you use a white or pale coloured T-shirt.

Make sure  you buy the right paper for iron-on transfers

> Bear in mind that ironing will produce a mirror image, so set your image editor or printer to create this first if there is text on the picture or if reversing it would spoil the finished image. Always test print on ordinary paper to check colours and readability.

Having printed on the coated side of the transfer paper using 'Transfer Paper Mode' or 'Normal Paper' at the best print quality, leave the printed image to dry for about five minutes before cutting it out, and remember to add a narrow margin to set off the picture.

You can now position it face down on a plain ironed T-shirt and iron it at the hottest, non-steam setting. It's best to press down very firmly and then lift off the iron gently before moving to a new area. Make sure that you cover the whole image, including corners, and keep ironing until the backing paper has changed colour.

Ideally, you will be able to peel off the backing paper fairly easily, but take care if going for a glossy finish as you are meant to leave the paper on until it has cooled. This *can* make it hard to remove the paper completely, without leaving tiny pieces on the image.

The final part of the process involves 'fixing' the image by covering it with a plain white piece of paper and ironing over this for a few seconds.

> It's crucial that the ironing board is very firm or you will find the edge of the iron leaves unattractive ridges over the whole image.

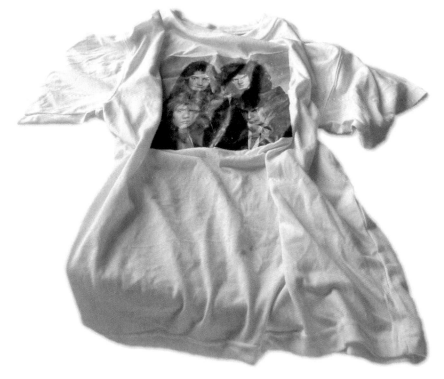

Tailor-made present for a teenager

## Posters

It can be tricky to print out pages to join together, so if you want to produce a large poster using a number of A4 sheets, download one of the free programs available from the internet.

One example is *Ace Poster,* which can be found at **www.aceposter.com** Once it is on your computer it is very straightforward to use. Simply click the 'Open' button to bring in your photo, change the size if you don't want the default poster dimensions, and print the required number of sheets.

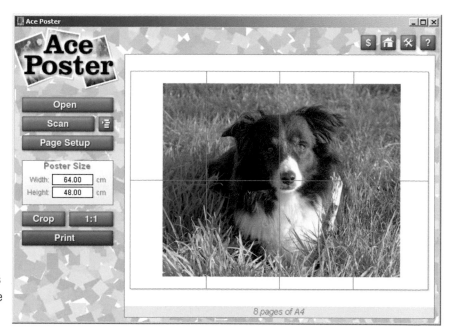

Creating large posters can be easy if you use a dedicated program

## Passport photos

With the right printer (which must be of high quality), or by using a mail order or high street print shop, you can now avoid those little passport photo kiosks or having to employ a specialist photographer to produce acceptable passport photos.

The Passport Office has regulations governing every aspect of the print quality, though, so you must follow the instructions or your photos will be rejected. The rules are set out in a file you can download from **www.passport.gov.uk** and it also gives examples of acceptable and unacceptable photos.

In summary:

1   You need two recent and identical photos.
2   They must be 45mm high and 35mm wide, but not trimmed to fit these sizes.
3   The background must be plain and off-white, cream or a light grey colour.
4   Use low-gloss, plain white photo-quality paper with no embossing or printing on the back. *One* photo may need to be countersigned on the back, but the other must have no writing front or back.
5   Do not mark it in any way – for example with paperclips – and do not use prints that are copyright (in other words, produced by a professional photographer for another purpose).
6   No-one else should be visible.
7   You should be facing directly into the camera with your head in close up, filling most of the print (from chin to top of head should be 29–34mm high or 21–34mm for children under 11).

The photos need to be clear and in sharp focus. There should be no shadows on your face and you should not be grinning or turned away. If you wear glasses, these must not be heavy or tinted or obscure your eyes, and you should avoid reflection or glare. You should also take care that there is no hair falling over your face as they will not accept anything that covers the outline of your eyes, nose or mouth. This means that you should not wear a hat or scarf unless for religious purposes.

If you don't have a good enough printer, follow the instructions from the Passport Office to take a suitable picture and then use one of the many online services available (such as that offered at **www.mypixmania.com**).

## At the end of this chapter you should be able to...

♦ Open a picture and print one copy at a resolution of 72dpi and another at 300dpi while keeping them the same size.

♦ Compare the quality of the prints. (Print onto ordinary paper to save wasting expensive photographic paper.)

♦ Print the same picture as a black & white (greyscale) print.

♦ Create a contact/index print of 8 to 10 of your pictures.

♦ Find out the cheapest place to have a set of 6" x 4" photos printed by comparing different online print services.

# Sending photos by email

We've all attended a special occasion, such as a wedding, graduation ceremony, 50th wedding anniversary or a relative's first stage performance, and wanted to send off photos of the happy event straight away to friends and members of the family unable to attend. Well, with email, it's amazingly simple to do.

Even if you don't own your own computer, you can set up an email address on the internet and use machines in a library or internet café to send off photos stored on your own CD.

## Image size

The size of picture files varies greatly, depending on the camera used and the file format in which they were saved. The best types of file for sending pictures electronically are compressed JPEG files. This is because a picture that was originally 274 KB in JPEG format, for example, becomes 1.84MB in BMP format, 2.19MB in PNG format and 2.6MB in TIFF format – in other words they are much bigger, take longer to send and can clog up the recipient's mailbox.

## Attaching a picture to an email

When you want to send someone a picture:

1  Open and create an email message as normal.
2  Now click the 'Attach' button ![attach icon] or go to 'Insert – File Attachment' which will open your computer folders.
3  Search for the file in the appropriate folder and, when it is visible in the window, select it and click the 'Attach' button.

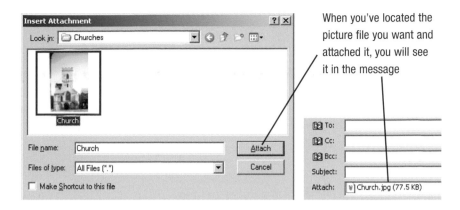

When you've located the picture file you want and attached it, you will see it in the message

4 You will return to your message and will see the named picture file showing in a new 'Attach' box.
5 Complete the message and send it in the usual way.

## Sending a picture inside a message

If you prefer, you can insert the picture directly into the message. If this is combined with a 'stationery' design, you can create quite unusual electronic messages.

To insert a picture into a message:

1 In the 'Format' menu, set the option 'Rich Text (HTML)'.
2 On the same menu, click 'Apply Stationery' and add a coloured border or background.
3 Type your message and then go to 'Insert – Picture'.
4 Browse for the picture and click 'OK' and it will appear in the message.
5 If you don't set position options when browsing, right-click the picture to choose a position for it in the message.

> If the picture is too big to display properly, delete it from the message, open it in your image-editing software and resize it before trying again.

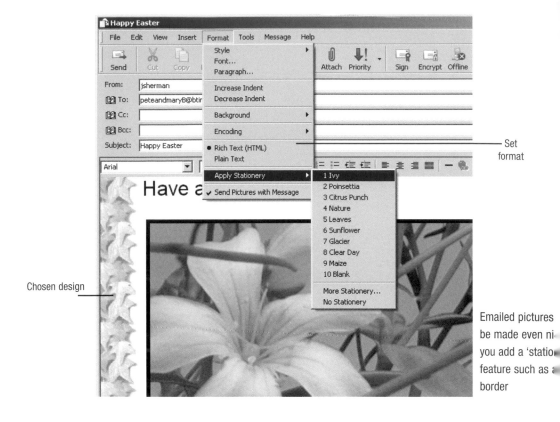

Set format

Chosen design

Emailed pictures be made even ni you add a 'statio feature such as a border

## Receiving an attachment

If you receive a photo attached to an email, you can double-click the file name to open it directly on the screen, or you can save it in a folder on your computer.

When you try to open it, you may see a warning that suggests you save it first of all so that you can check it for viruses, but you can override this instruction if you are sure of the source of the message.

To save a large number of photos:

1   Go to 'File – Save Attachments'.
2   Select a suitable folder location for the files and click 'Save'.
3   You can either save them all or hold down 'Ctrl' as you select (by clicking on them) individual files listed in the attachment window.

It's a good idea to save pictures that have been emailed to you to prevent your mailbox filling up

Find correct location for the files

# Compressing picture files

If you want to make a picture even smaller, to save space, you can compress the file to do this. You can either use the built-in compression facilities provided by Windows XP computers before sending it, or use one of the free zipping programs available on the internet, such as *WinZip* (**www.winzip.com**). This 'squashes' the file into a special type of folder known as an 'archive'. It looks like a normal yellow folder with an added zip.

In Windows XP, find the file and use one of the following methods.

**Either:**

a.  Right-click the file and select 'Send To – Compressed (zipped) Folder'.

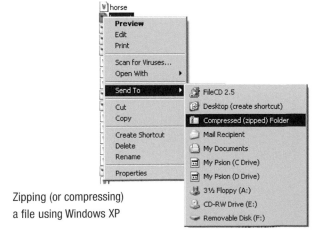

Zipping (or compressing) a file using Windows XP

✳ This will create the archive that contains the file in a compressed form. It will have the same name as the original file, although you can always rename it. (If there are a large number of files listed in the window, you will find the archive at the end of the list.)

Find your archive of zipped files
at the end of your list of folders

You can select a number of files and compress them at the same time or even drag extra files into the archive directly on screen, but note that the archive will be given the name of just one of the files.

✳ To attach the archive to an email, right-click and select 'Send To – Mail Recipient'. A new message window will open, with the archive already attached.
✳ Change the subject and message that will have appeared automatically and treat the email in the normal way.

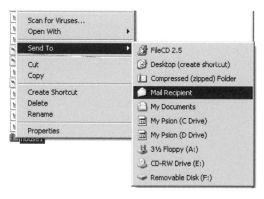

Right-click a file to send it as an attachment

Or:

b. Select the picture and use the 'File and Folder Tasks' pane option to 'Email this file'. If the pane isn't visible, click the 'Folders' button on the toolbar.

Using the email option in the Tasks pane

✳ In the dialogue box that opens, you will see a thumbnail of your picture. Select 'Make all my pictures smaller' and either click 'OK' or first select 'Show more options' and choose the picture size. ('Small' is usually selected by default, but, if you know your recipient has a fast internet connection, you may want to choose 'Medium' or 'Large'.)

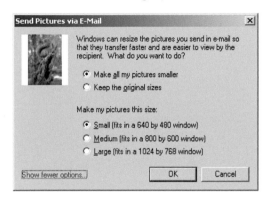

Take advantage of the Windows XP compression system to save space when emailing a picture

✳ When you click 'OK', a status bar appears as Windows resizes the file. Then a new message is opened in your email program with your picture attached.

✳ Windows inserts a message saying the file is attached, as well as the name of the file in the subject box. Delete both of these and add your own subject and message instead. Complete the email details and you are ready to send.

## Sending several pictures at one time

You can use the 'Send Email' facility in the 'File and Folder Tasks' pane to attach several photos to an email at the same time:

1  Go to the folder containing the pictures you want to email.
2  Select the group of files. To send every file in the window, hold down 'Ctrl' and press 'A' at the same time. To select a range of adjacent files, click the first file and then hold down 'Shift' as you click the last. All of the files in the range will be selected. If you only want certain files, hold down 'Ctrl' to select them individually.
3  In the 'File and Folder Tasks' pane, click on 'Email the selected items'.

Select all the pictures you
want to send from the folder

4   Remember to change the subject and main message details when
    your new message window opens.

Change
automatic
entries

You can delete the automatic text
entries and write your own

All files
attached

## Opening a compressed file

If someone sends you pictures in a zipped format, the name of the archive will be shown in the 'Attach' box. For one or two pictures, it is easy to open the archive, select the files and double-click them to open as normal.

For a large number of files, open the archive and then use the 'Extract' option from the Tasks pane. This starts the wizard.

When zipped files are sent to you, unzip them using the extraction wizard

Click 'Next', select the location for the files – you can always make a new folder for them at this stage – and they will be extracted. You can view them straight away or find them there when you next open the folder.

The extraction in progress

## Optimizing compression

Many image-editing programs include tools to compress files so that they are easy to send by email or display on a website.

One wizard to help you do this is available in *Paint Shop Pro:*

1   On the 'File' menu, click 'Export' and select 'JPEG Optimizer' or 'PNG Optimizer', depending on the format of your picture. The software will now compress it to its smallest size, although this may compromise the quality.

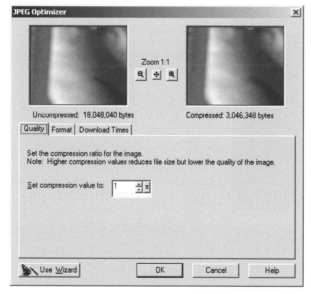

Compressing your picture in your image-editing software

2   To see the effects more clearly, click the 'Use Wizard' button and then change the slider position to move between size and quality.

It is up to you how much you want to compress the picture

3    Click 'Next' to review the results and continue to change the slider position until you have the smallest, but most acceptable, quality picture.

Quality too poor at this compression —

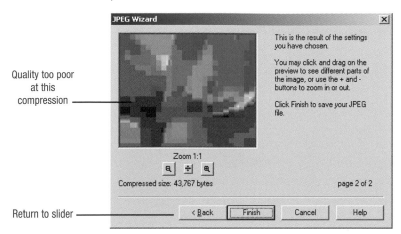

Return to slider —

If quality is compromised, go back and increase the picture size

4    You will then be able to save a copy of the picture to send by email or for online display.

## At the end of this chapter you should be able to...

♦    Attach pictures you have saved on your computer and send them.

♦    When a message containing pictures arrives in your inbox, save the attachments.

♦    Use Windows XP facilities or a zipping program to compress/zip any picture on your computer.

# Using photos in documents

Now your photos are on a computer, you can add them to any documents or publications you want to produce. Although many of the same menu options are available across a wide range of programs, there will be some ways in which each type of application differs when it comes to working with pictures. The information in this chapter relates to working with Microsoft Office XP. It explains how to add pictures to a variety of documents and to make the best use of them once they are in your document.

## Adding a picture

There are two different ways to add a photo to any document, depending on whether it is easy to have the image open on screen or not. You can either copy and paste the photo into the document or add it using the 'Insert' menu.

### Copy and paste

If you have already been working on a picture – perhaps viewing it straight from the camera or after editing it in an image-editing program:

1   Select all or part of the picture and then choose the 'Copy' option on the 'Edit' menu or toolbar.

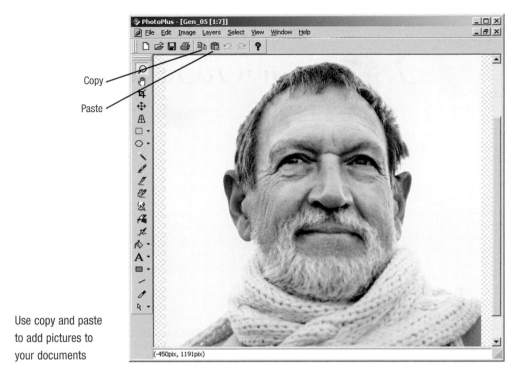

Copy

Paste

Use copy and paste
to add pictures to
your documents

This places the picture in the computer's memory – the clipboard –
where it will remain until you paste it into your new document.

2    Open the new document and click where you want the image.

3    Then select the 'Paste' option and it will appear on the page. It can
now be treated like any other picture you may have added from the
Clipart Gallery or the internet.

## Inserting from file

If you are working on your document and want to add a picture that has
been saved somewhere on your computer, you can add it using the menu:

1    Open the 'Insert' menu and select 'Picture – From File'. (You should
also have the option on the menu to acquire a picture directly from
your camera or scanner if it is connected.) Alternatively, click the
toolbar button ▣ on the 'Drawing' toolbar at the bottom of the
screen.

2    This will open up your folders and you can search for the file in the
normal way.

3    When it is visible in the dialogue box window, select it and click the
'Insert' button. It will appear on the page.

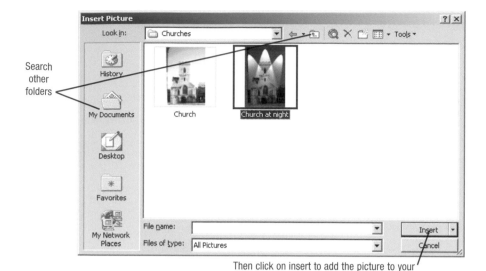

Search
other
folders

Then click on insert to add the picture to your
document

## Crop

We have already seen how useful the crop facility in image-editing
programs can be. All Microsoft Office programs have a 'Crop' tool. To use
it, you click on it and then drag in the boundary on the edge nearest the
unwanted part from a central sizing handle (the black squares round the
edge of the picture). When the new boundary is in the right place, release
the mouse button and the part of the picture left outside the dotted line
disappears.

The crop tool

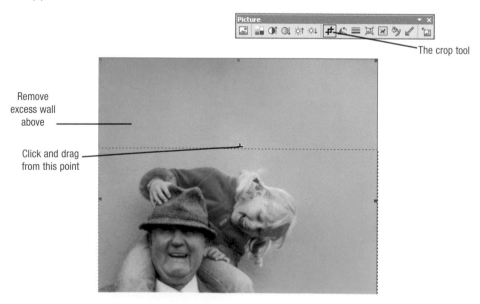

Remove
excess wall
above

Click and drag
from this point

If it is too large to work with, go to 'Format – Picture', click the 'Size' tab and set a width of a few inches or centimetres. Click in the height box to set this automatically and then click 'OK'. You will now be able to resize the picture using your mouse.

You could also draw a text box on the page (see page 144) before inserting a picture, and it will then be resized automatically to fit inside.

## Working with the picture

Once you have got your picture where you want it in your document, you can make changes to it. To do this, click the picture to select it and then use the toolbars to make your changes. (If no toolbar appears, right-click and select 'Show Picture Toolbar'. But it's usually at the top of the screen between other toolbars.)

You can rotate or crop the picture or increase contrast or brightness. You can also drag a boundary in or out to change its size.

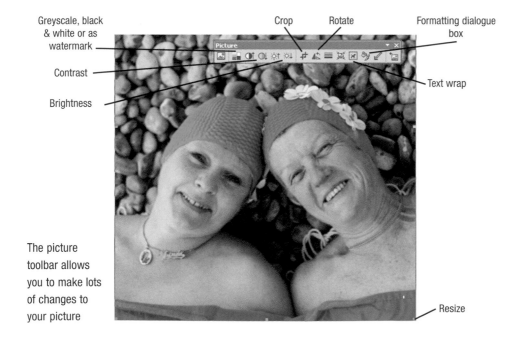

Greyscale, black & white or as watermark

Contrast

Brightness

Crop

Rotate

Formatting dialogue box

Text wrap

The picture toolbar allows you to make lots of changes to your picture

Resize

## Borders

If you want to add a simple border to your picture, click the toolbar button ▣. For a choice of more elaborate styles, colours and widths, open the 'Format' menu and select 'Borders and Shading'.

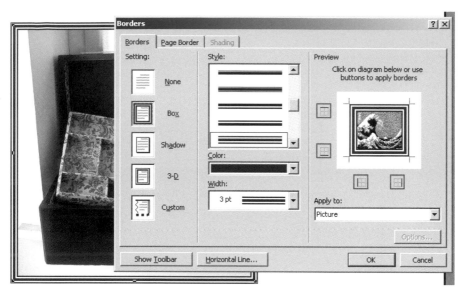

Add a colourful border by selecting 'Style' and 'Colour' from the borders box

# Word-processing

### Reducing picture file size

Any pictures added to a document will be at their original resolution. If you want to save room on your computer when you save the file, you can use the 'Compress Pictures' option on the 'Picture' toolbar. This will let you choose a suitable resolution, for example for printing, and will discard extra information that is still stored after cropping or resizing the image.

### Text wrapping

When you add a picture to a block of text, you can choose how the text wraps round the image. In some cases, a clear margin would look best, but you may prefer the text quite close to the picture, running right through it, or for it to be above and below but not alongside the image.

Top and bottom, or tight wrap styles produce very different results

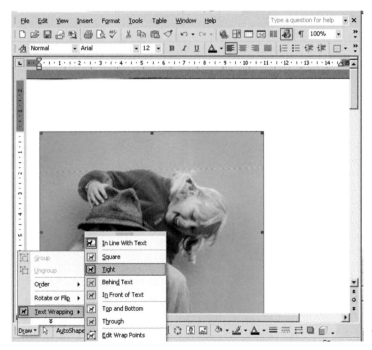

Find a wrap option
from the Draw menu

To set the spacing and text position exactly, go to
'Format – Picture – Layout' and click the 'Advanced' tab.

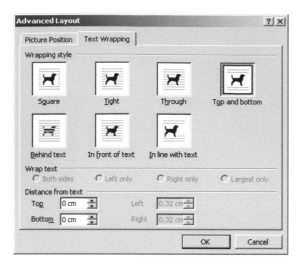

You can use a menu from the 'Advanced' tab to position your text more precisely

Once you have applied a text wrap, you will find that any borders you have added can now be amended and coloured from options available on the 'Drawing' toolbar.

The toolbar offers a range of border styles, colours and weights

## Move pictures

In word-processing, you can use the alignment buttons to set a picture on the left, right or in the centre of the page, but you will find that you cannot actually drag it across the page using the mouse.

If you want to be able to do this, click on the picture and apply a text wrap option from the 'Picture' toolbar or 'Draw' or 'Format' menu. As well as allowing you to set a wrapping option, this also lets you work with the picture differently. You will now see *white* rather than black sizing handles (for resizing) and a green free rotate button, and you will find it easy to rotate or move the picture into a new position.

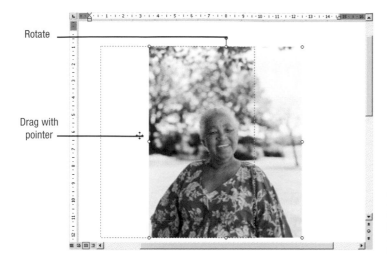

Rotate

Drag with
pointer

After selecting a
picture, you can
drag it round the
page or rotate it

## Group pictures

When there are several pictures on a page, you may want to select them all at once. This is particularly useful if you want to copy them all elsewhere or to resize or format them at the same time. They must show *white* sizing handles, so first apply a text wrap to each picture if you have not already done so.

Now you can draw round them all after clicking the 'Select Objects' arrow and then go to 'Draw – Group'. The selected pictures will become one.

To change one part of a grouped picture, select 'Draw – Ungroup' and carry out the formatting before regrouping or grouping again.

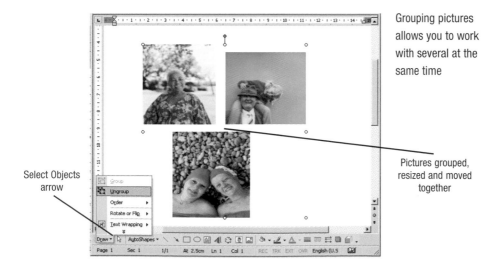

Grouping pictures
allows you to work
with several at the
same time

Pictures grouped,
resized and moved
together

Select Objects
arrow

## Layers

As we saw in Chapter 9, pictures or other objects can be arranged in layers over each other on the page, and can then be reordered to reveal those underneath.

If, for example, you would like a picture to have a shaped or coloured background and border, you can do this fairly easily by drawing and filling a shape and then sending this *behind* the picture:

1 Draw a shape using an 'AutoShape' from the 'Draw' menu.
2 Size it to be just larger than the picture, then add a colour fill or line from the toolbar.

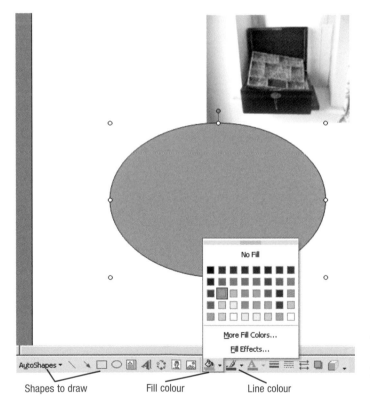

Choosing a shaped and coloured background for your picture

3 Drag it over the picture and then choose an 'Order' option from the 'Draw' menu. (You may have to select an odd one, such as *Send Behind Text*, to reveal the picture.)

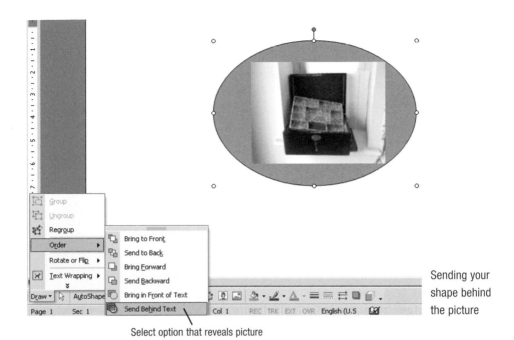

Select option that reveals picture

Sending your
shape behind
the picture

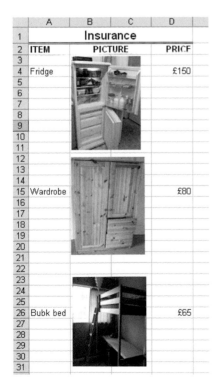

| | A | B | C | D |
|---|---|---|---|---|
| 1 | | Insurance | | |
| 2 | ITEM | PICTURE | | PRICE |
| 3 | | | | |
| 4 | Fridge | | | £150 |
| 5 | | | | |
| 6 | | | | |
| 7 | | | | |
| 8 | | | | |
| 9 | | | | |
| 10 | | | | |
| 11 | | | | |
| 12 | | | | |
| 13 | | | | |
| 14 | | | | |
| 15 | Wardrobe | | | £80 |
| 16 | | | | |
| 17 | | | | |
| 18 | | | | |
| 19 | | | | |
| 20 | | | | |
| 21 | | | | |
| 22 | | | | |
| 23 | | | | |
| 24 | | | | |
| 25 | | | | |
| 26 | Bubk bed | | | £65 |
| 27 | | | | |
| 28 | | | | |
| 29 | | | | |
| 30 | | | | |
| 31 | | | | |

Pictures in a spreadsheet
can help you identify items

## Spreadsheets and databases

You can illustrate a spreadsheet or database using
your own photos. This can be particularly useful if
you want to keep a pictorial record of household or
personal items for insurance purposes, for example.
If you run a small business, it will help you identify
those items you have bought or sold.

You just use exactly the same techniques to add
pictures as were explained at the beginning of this
chapter – copy and paste or 'Insert – Picture –
From File'.

## Desktop publishing (DTP)

Now that you are getting to grips with your digital
camera and how to manipulate your pictures on the
computer, you can have the pleasure of being able to
make gifts for other people using your own photos.

You can produce something acceptable using a word-processor, but to create thoroughly professional-looking publications, you really need to invest in a desktop publishing (DTP) package such as *Adobe PageMaker, Corel Picture Publisher, Cosmi Desktop Publisher, Microsoft Publisher* or *Serif Page Plus.* You will also find cut-down packages that concentrate on one item, such as cards or badges.

With the more advanced packages, you can start from scratch with a plain page or adapt one of the designs in their catalogue. Whichever you choose, you will find that you can edit the picture in a similar way as when using a word-processing package but you will find it much easier to move, position and change the picture.

To start a blank publication in *Publisher,* for example, open the program and select the option from the 'New Publication' pane.

You can add a picture to the page:

* from the 'Insert' menu;
* after clicking the 'Insert Picture' toolbar button and drawing a box on the page; or
* by using copy and paste.

The toolbar is slightly different to that in *Word,* as it offers the added option of acquiring the picture directly from a scanner or camera.

You will see that the picture already shows white sizing handles and a green rotate circle, and so can be rotated or moved easily around the page. You can also add a border directly from the 'Picture' toolbar by selecting a line option.

Acquire picture from scanner or camera

Desktop publishing makes working with pictures a breeze

If you double-click a picture, you open the 'Open' box and can find another picture. If you select it, it replaces the original one.

DTP programs use 'frames' or boxes for text and pictures, so that these can be arranged round each other easily. For example, text is entered after clicking the 'Text Box' tool and drawing a text box on the page.

> Zoom in and out regularly to see how the whole page is shaping up. To do this quickly, either press the 'F9' function key at the top of the keyboard or click the 'Zoom In' and 'Zoom Out' buttons on the toolbar.

## Cards

If you want to design a greetings card, you can use the catalogue that comes up each time you open the program or select one from the 'File – New' menu:

1 Browse through the publication types and select a style of card that you like.

This program helps you create your own cards

2   When it opens on screen, make your selection from the choice of
colours, layouts and fonts offered in the tasks pane.

Find other
options

Text box

Customise your card
with the styles and
colours on offer

Sections of the card

3   With a DTP package, the numbers at the bottom of the screen
normally relate to the actual pages in your publication. For cards,
however, they relate to the relative *sections* of the card, which is
actually printed out onto a single sheet of A4 paper: 1 is the front,
4 is the back and 2 & 3 are the inside pages. Click any tab to work
on that page.

All four sections of the card will print out on a single piece of paper

Pages 2–3 (inside)

Page 4 (back)

Page 1 (front)

4   Click on any text to delete or retype it, and add your own in a text box drawn on the page.

5   Delete any default pictures and find one of your own photos to replace it. Add your picture using the insert or copy options.

6   You may find you need to change fonts or re-colour some of the shapes after adding a photo. You can return to any tasks pane choices by clicking the menu or back arrows.

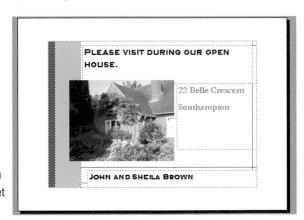

Once you've added your own picture, change colours to get a good match

7   For some cards, there may be a suitable greeting in the task pane on the left that you can add to the front or inside pages.

Some packages have a range of verses – if you like them you can add them to your card

8  When the card is finished, go to 'File – Page Setup' to select the style of fold, orientation and paper size before printing.

You can decide how your card will fold when it is printed

## Calendars

You can also use the catalogue of professionally designed publications to create your own calendar.

Under 'Calendar Options', make sure the months and years are accurate, or click the option to change the date range.

Make sure your dates are correct!

You will either need a very good single photo or 12 different seasonal pictures, depending on the style of calendar you pick.

Choose the image you want for each month of the year

## At the end of this chapter you should be able to...

♦ Insert a picture into a word-processed document.

♦ Crop it to remove any unwanted parts.

♦ Reduce it in size and position it in the middle of the text, applying a text wrap.

♦ Add a border to a picture.

♦ Draw a shape on the page, fill it with colour and send it behind a picture as a coloured background.

♦ Save the document with a different name.

♦ If you have a DTP program, use one of your pictures to create a birthday card.

# Displaying your photos

Once you have taken some photos, there are many ways in which they can be displayed or shared with others. This chapter will show you how you can display your pictures on a computer, on the TV, on the internet or even in a digital 'picture frame'.

## On a computer monitor

If your computer screen resolution is 1024 × 768 pixels and you want your picture to take up half the viewing area, then it should be 512 pixels wide. (As some people have lower resolution monitors, you may want to reduce your image size to fit an 800 × 600 display if sending a picture electronically).

To change the display settings of your monitor, go to 'Start – Control Panel' and select 'Display', or right-click on the desktop and click 'Properties'.
On the 'Settings' tab you can increase or decrease screen resolution.

If you particularly like one of your pictures, there is an option in the Windows XP Picture Tasks pane to display a photo on the desktop. If you open the photo in *Microsoft Paint,* you can select 'File – Set as background' for the same effect.

Change your monitor settings to diplay pictures at their best

If you really like a picture, why not set it as your desktop background?

To change the image, select 'Control Panel – Display', click the 'Desktop' tab and select an alternative from the drop-down list.
You can also set the picture as tiled, centred or stretched and choose a different colour background.

You can change the background as often as you like

Select an alternative

How the picture is displayed

Background colour

# Electronic photo frames

Nowadays you can find various electronic photo viewers in the shops, from manufacturers such as Phillips. They have small screens and can read a range of memory cards, so you can display different pictures in a 'frame' on your desk. They cost between £50 and £100.

The latest thing – an electronic picture frame!

# Slide shows

Presentation software, such as *Microsoft PowerPoint,* provides a means of displaying one or more photos without any extra objects on screen, such as menus or toolbars.

When you open the program, you are presented with a single slide. Copy and paste one or more photos and arrange them on the slide, either as single photos or a montage. Resize them so that they make an attractive display.

PowerPoint lets you display your photos as a slideshow

Thumbnail of slide

Copy, position and resize one or more photos

Slide show button

If you want one photo per slide, add new slides by clicking a thumbnail and pressing 'Enter'. Click any thumbnail to work on that slide in the main window.

If the slide has 'placeholders' – ready-made boxes for adding text – you can click the edge of any box and press the 'Delete' key to remove it, or you can use it for adding text to the slide.

You can use the 'Placeholder' to type in a title

You might like to show your photos properly to impress your friends or family:

1   Make sure the first slide is selected and then click the 'Slide Show' button 🖵 in the bottom left-hand corner of the screen.
2   Move between slides by clicking the mouse or pressing the 'Page Down' key.
3   Press the Escape ('Esc') key if you want to return to the program before reaching the last slide.

When you run a slideshow all you see is the pictures – no menus or toolbars

If you want to be more ambitious, explore the extra features in your software and add sounds and transitions between slides.

> As we saw in Chapter 5, many image-editing programs – such as *FinePix Viewer* – also offer the option to run slide shows, but you won't be able to work on the pictures in the same way or add any effects.

For sophisticated slideshows, add sound effects and 'transition' styles

## On the camera

Don't forget that, if you want to show someone your new kitchen or tropical fish, you can always take your photos with you on your camera when you pop round. Before you go, attach the camera or memory card to your computer if the pictures have already been saved, and copy across the photos that you want to share.

YOUR DIGITAL CAMERA MADE EASY

Although the pictures will be small, your friends will get a good idea just from looking at them on the LCD screen. Some LCDs have a zoom function so that you can show more detail of particular parts of the image.

## On TV

Most digital cameras come with a video-out cable. This means you can connect one end of the cable to the video-out of the camera and the other end to the video-in of the TV. When you play back the pictures on the camera, they will be displayed on the TV. But this will only work with the photos actually on the memory card in the camera at the time.

To show more photos, you can buy a photo viewing device, such as the *SanDisk Digital Photo Viewer.* This is a set-top box that reads memory cards and has a video-out port that connects to the TV. You can buy one for around £30 to £40.

Nowadays, many DVD players also read memory cards, and of course you can display home-produced DVDs of your favourite photos (see Chapter 7 for information on burning to disk).

## Online photo albums

Many internet companies – including those that will print your photos – have websites that provide space for your personal images. After these have been 'uploaded' to the site, they will be displayed in a 'photo album'.

You can arrange for the site to send the website address and any password to selected friends and family by email so that they can view the photos and perhaps order their own copies. You can also publish them for others to view and even join a community of people interested in similar photographic topics.

Companies that offer a joint printing and album service include *PhotoBox, Bonusprint, Myimagebox, myPixmania* and *Kapture-it,* as well as supermarkets such as *Tesco.* Sites such as *Flickr, Photobucket, Smugmug, Webshots* and *Fotothing* are more for those interested in sharing.

Share your photos in an online photo album

Once you have registered on your chosen website, take a tour to find out what is on offer and follow the instructions to add your photos and edit backgrounds and designs.

Some websites allow you to send your photos by email, but most will ask you to upload them from your computer. In order to do this, you may be asked to download a special program first, such as *Easy Upload,* to help you publish your images. You then just follow the instructions to locate and transfer your pictures to the website.

In some cases, the companies offer a full website building service, rather than just a simple photo album. Depending on which services and how many photos you want to display, as well as whether or not you will tolerate advertisements on your site, the prices vary from being completely free to over £100 per year. Many companies offer a free trial before you finally purchase the service.

Some photo sharing websites (such as **www.flickr.com**) help you search for photos with a common theme by letting you give your photos a 'tag', which acts as a keyword or category label.

make the most of any tagging options – these help people search for similar photos

## Personal web pages

There are many books available on how to create your own web page, but you will find that hosting companies and Internet Service Providers now offer templates and guides that make it extremely easy to do so without the need for any special knowledge or having to purchase a web authoring software program.

If you like the idea of having your own web pages, think about:

* The contents and layout of the pages
* Which pictures you want to include and how you want them displayed
* How your pages will link to each other and external websites.

> As you will be publishing the pages and regularly changing pictures or editing the text, keep all the images and web pages together in a single folder on your computer.

Some image-editing and photo management programs, such as *Picasa,* offer help in designing pages and collecting them together in a folder for easy uploading.

Use software such as Picasa to build up a folder of photos ready for the website

You will be offered a range of layouts from which to choose.

Choosing your preferred layout

Make a note of where your folder of pages will be stored, ready for when you publish online.

A final chance to view the appearance of your web pages

## Free software

If you don't have appropriate software, you can download a free program from the internet – for example:

*   www.freeserifsoftware.com
*   www.webstudio.com

When you have registered to obtain the key to the program, open the 'Help' menu for guidance. One option is to take a tour.

Always follow the tutorial or take a tour to familiarise yourself with new software

This offers a tutorial on the main aspects of the program.

The WebPlus tour shows you how a website is created

The easiest way to start setting up a page is to use the wizard:

1   Pick one of the templates and then make changes from the selections in the wizard pane.

Use the wizard to choose your preferred page layout

2  When the wizard finishes, you will have a basic page.

Your page is
starting to take
shape…

3  Select any part to make changes, using the 'View – Zoom' option to
see it in detail. For example, click the 'Text' tool to add your own text.

Add
text

Add your own text to web pages

4  Click the 'Insert Picture' tool to find a picture.

Insert picture

Click on a toolbar button to add pictures and select a source

5   When it appears, resize or move it in the normal way with the mouse.

Resize and move your picture to create the desired effect

Some packages offer a quick way to create smaller pictures (thumbnails) for your web page, which will download more quickly.

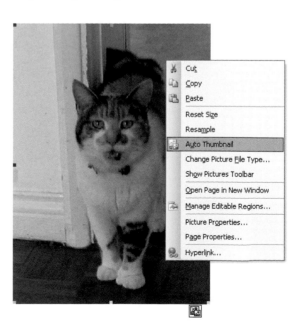

You can reduce your pictures to thumbnails – they load more quickly and save you time

You can also create a caption for the picture:

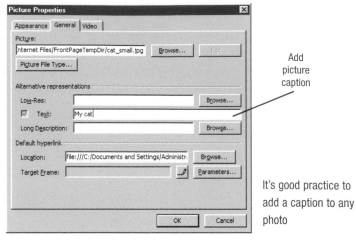

1  Right-click the picture on the page.
2  Select 'Picture Properties'.
3  Type your caption text into the box provided.

Add picture caption

It's good practice to add a caption to any photo

The caption will be displayed when the mouse hovers over the picture and will help those whose computers are not set to download images automatically.

## Web authoring programs

If you want help designing your pages but already have a web authoring package, such as *Microsoft's Frontpage* or *Macromedia's Dreamweaver,* you may prefer to use one of the many online templates.

The caption comes up when your mouse is over the image

Anyone can learn from the professionals, so base your website on ready-made templates

If you use your own ISP's free web space, or that provided by a hosting company, you will need to follow their instructions to upload the files onto their server (a special computer used for hosting web pages). In some cases, you may first have to download a file transfer protocol (FTP program) to help you, or you may be able to use the built-in facilities provided by software such as *FrontPage*.

When you're happy with your web pages, don't forget to send your website address (URL) to friends and family so that they can view your site from their own computers.

Follow the advice carefully for hassle-free transfer

A finished home-made web page

# Selling items on eBay

Selling items on the internet is big business nowadays. You're probably aware of the phenomenal success of the auction site *eBay,* where you can advertise your unwanted goods for sale, and you can also advertise on other sites, such as *Tazbar, QXL* or *Ebid.* You can find an up-to-date list of online auctions at **www.auctionlotwatch.co.uk** or **www.uk250.co.uk/OnlineAuction**

If you want to sell an item such as a boat, car or motorbike, or get rid of unwanted books, there are also a wide range of specialized auction websites.

As it is very hard to buy sight-unseen, successful sellers will always display at least one picture of the item, and possibly several if it needs to be viewed from different angles.

A quick visit to the website at **www.ebay.co.uk** will show you how poorly many items are photographed. To make sure your item is presented in the best possible way:

1   Never supply a picture that is out of focus.
2   Sort out the lighting so that all details are clear.
3   Fill the frame with the item.
4   Keep the background completely neutral, so that nothing detracts from your item.
5   If you are mentioning minor defects, add a clear picture of these so that people's fears are assuaged.
6   Put the item in context – for example, if you can, move it out of a garage or shed so that it is not surrounded by unappealing junk.
7   Be honest with your photo – does it make you want to buy? If not, take the time to photograph it again more carefully (or take the item to your local charity shop).

You will need to register on the website and then follow the selling instructions.

After selecting a suitable category, add details of the item and then click 'Browse' to find the first photo you want to publish. This will be free and it is only a few pence for each additional picture.

You can also choose to show a thumbnail of the item on the search page, as well as larger pictures on your main selling page. For the basic service, pictures should be under 2MB in size and in JPEG format.

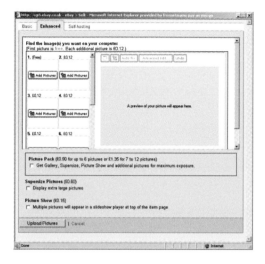

Adding photos to eBay is very simple – just click the 'Browse' button

Having entered a starting price and postage details, and decided at what time and day you want the auction to begin, preview your page to check that your photo and everything else looks right before submitting the listing.

Check the page carefully before going live

# Photomosaics

If you're interested in finding new ways to present your pictures, you may want to consider photomosaics. These are software programs with a huge library of small pictures that are then combined by the software into a mosaic picture, based on one of your own photos.

Programs that offer this art form include *Advanced Photo Mosaic Maker, PhotoMontage 2000* and *Mazaika.* One program that you can try for free for a few days is *Easy Mosaic 2005* (available from **www.ezmosaic.com**).

When you have downloaded a photomosaic program:

1  Open the program and start a new project.
2  Double-click the window to browse for your photo.

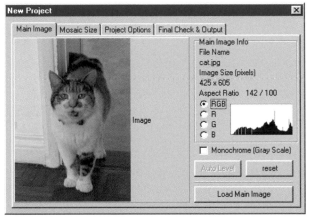

Find a suitable picture on which to base your mosaic

You can change picture colouring or make it black & white

3  On the 'Mosaic Size' tab you can set the number of cells (equal to the number of pictures) you want in the mosaic, and look at the general pattern that will be created.

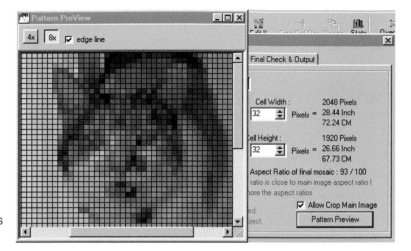

Set the dimensions
for your mosaic

4 On the 'Final Check & Output' tab, click the button to create
the mosaic.

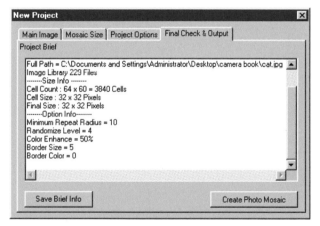

Click 'Create'
to build up
your picture

A progress indicator will be visible on the main window as the
pictures are added.

Watch the progress
of your mosaic

When your mosaic is created, you will see in detail all of the tiny
images making up the picture in the main window.

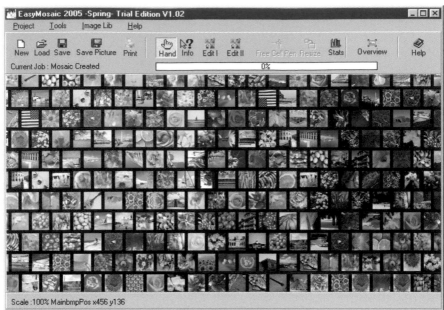

The mosaic in close-up, showing its constituent part

5   Click the 'OverView' button to see your picture in full, and then save it to your computer.

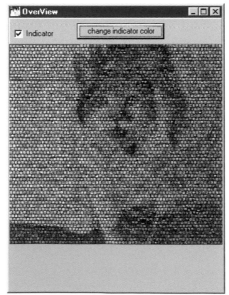

The final version

## Special gifts

If you would like to give someone a very personal and unusual gift, you can now order T-shirts, mugs, mouse mats or key rings, for example, with your own photos on them. You order them from the same online

Get creative with your photos -
turn them into high quality gifts
Sign in on the left to create a wide
range of gifts for you, your family
and friends.

Your own photos can be added to gift items

companies that produce normal prints. All you need do is register, upload the pictures and make your purchases.

### At the end of this chapter you should be able to...

♦ In a presentation program, such as *Microsoft PowerPoint*, make some slides and run a slide show to display your favourite photos.

♦ Upload photos onto **www.ebay.co.uk**

♦ If you don't have any software that offers web page designs, download *WebPlus* from the internet (at **www.freeserifsoftware.com/software/WebPlus**) and install it on your computer.

♦ Visit your ISP's website and follow the tutorial on publishing web pages.

# Appendix – Other sources of photos

We cannot all go to Africa or dive under the sea to take a photo, and yet there may be occasions when you would really like the picture of a lion or an octopus in your documents. You are also likely to have albums, large envelopes or drawers of old photos which you might enjoy having available on your computer. So it's worth knowing how you can find different sources of digital photos rather than always having to take them yourself.

## Scanner

The method used for transferring old photos onto your computer is known as 'scanning'. It captures the pixels in the picture to produce a digitised copy. You can scan photos that were taken with a conventional camera as well as print images, 3-D objects, slides or negatives.

Most scanners used in the home are flat-bed scanners. Your picture is placed face down on a glass plate and the light source and sensor move slowly across the picture underneath the glass.

There are various types of scan you can choose, including one that attaches the image directly to an email message. For a photo you want to edit straight away, select an 'Image Scan'.

Select the most
appropriate type
of scan

If you know you just want to send the pictures by email or use them on the
internet, you can scan at 72 dpi and save the files as JPEGs. If you are
going to print out the photos, you would set the resolution to around
200–300 dpi and save them as either JPEG or TIFF files. Some scanners
will have default settings that automatically select an appropriate resolution
and file type.

Your scanner will offer a pre-scan or preview facility so you can drag in the
boundary to alter the size of the scan (if the picture you want is only a
portion of the whole page) and make changes to contrast and resolution.

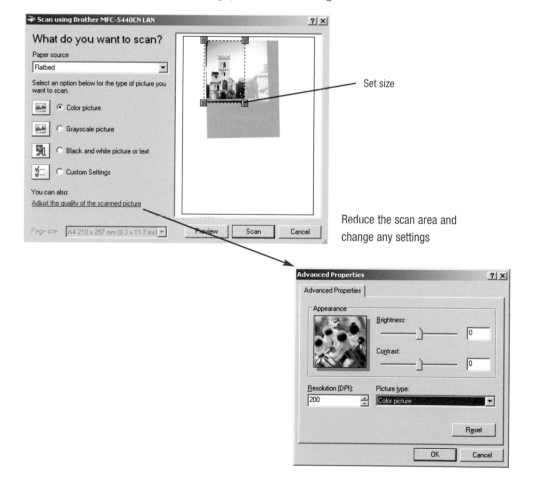

Set size

Reduce the scan area and
change any settings

Then you take a full scan, which usually takes a few moments, and the picture will appear in your editing software window. It can now be saved and edited in the same way that you would use digital camera pictures.

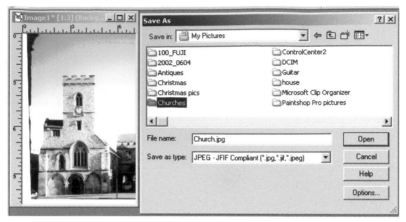

Save a scanned picture to your computer in the normal way

## CDs

Friends may send you photos on disk, and many CDs that have images on them are now available to buy, or you could borrow them from the library. The pictures will appear listed in the D: drive of your computer when you have placed the disk in the correct slot.

CDs can be a source of pictures

## World Wide Web

Images on the internet can be downloaded easily onto your machine. Simply right-click an image and then select 'Save Picture As...'

Saving a picture
from a website

When your 'Save As' window opens, select the location where you want to save the image. Rename the picture if necessary to make sure it will be easy to find again in future. Keep the file type as JPEG or GIF, which are the two types of file normally used for web images.

## Copyright

It's very important to bear copyright in mind when using professional photos obtained commercially, whether from the internet or from printed material. It's illegal to use other people's photos for commercial purposes, although it's quite acceptable to look at them on your computer or use them in a limited way. Adding them to Christmas cards you want to sell is definitely not allowed!

# Jargon guide

**Aperture**   The opening in the camera through which light enters

**Archive**   To store items safely for the long term

**Archive folder**   A folder created to store compressed or zipped files

**Batch conversion**   Working on a number of files at the same time – for example saving them all as the same file type

**Browsing**   Searching for a particular file on your computer

**Burning**   Copying files onto a CD

**Burst mode**   Taking a number of camera shots in quick succession

**Clipboard**   Part of the computer memory that holds copied items temporarily

**Cloning**   Copying part of a picture and pasting it over another part – usually to cover unwanted areas

**Compressing**   Either zipping or reducing the size of a file, sometimes with subsequent loss of detail

**Depth of focus**   The distance in front of and beyond the subject that appears to be in focus. There is only one distance at which a subject is precisely in focus, but focus falls off gradually on either side of that distance, and there is a region in which the blurring is imperceptible under normal viewing conditions

**Desktop**   The opening screen visible when you start a computer

**Dialogue box**   Any window that opens from a menu offering choices of settings

**Digital zoom**   A method of increasing the apparent focal length at which a photographic image is produced. It enlarges a portion of the image, thus 'simulating' optical zoom

**Download**   To transfer files onto your computer

**Dpi**   Dots per inch – a measure of the resolution of a printed image

**Filters**   Ways of changing the appearance of an image by altering its pixels

**Fixed focus**   A camera where you cannot change the focal point of the subject

**Focal length**   A measure of how strongly the camera focuses or diverges light and the value used to calculate the magnification

**F-stops**   The quantitative measure of lens speed. The f-number is the diameter of the aperture in terms of the effective focal length of the lens

**Ftp**   File transfer protocol – the method for transferring files over the internet

**Gamma correction**   Correcting contrast and brightness of an image

**Histogram/levels command**   A graph of the distribution of red, green, blue, greyscale, hue, saturation, and/or lightness values in an image

**Hot shoe**   A mounting point on the top of a camera to attach a flash unit

**Hue**   The tint of a colour (for example red or yellow)

**Image-editing software**   Programs that allow you to manipulate images on the computer

**Image sensor/image chip**   A device that converts visual images to electric signals

**Image stabilisation/vibration reduction**   Techniques to increase the stability of an image

**Index print/contact sheet**   A number of small images printed together on a single page

**Initializing/formatting**   Cleaning and setting up a disk for storing information

**Interpolating**   A way to add extra pixels to make an image print

**ISP**   Internet Service Provider (such as *AOL, Virgin* or *BT*)

**JPEG**   Compressed file type commonly used for saving digital camera images

**Layer**   Some image-editing programs separate items added to a picture into layers, so that each can be edited independently

**LCD screen**   Liquid Crystal Display screen, such as those found in laptop computers and in new TV and computer monitors

**Lossy format/lossless**   When image files are compressed, some methods remove detail which is then lost – in other words, they are lossy

**Macro focusing/photography**   Close-up photography where the objects are still in focus

**Megapixel**   One million pixels

**Memory card**   Storage medium normally slotting into a digital camera

**Noise**   Random patterns of pixels that give an image a grainy or textured appearance

**Optical resolution**   The ability of a camera to distinguish, detect, and/or record physical details

**Optical zoom**   Using the optics (lens) of a camera to bring the subject closer

**PictBridge**   The technology allowing some cameras to transfer images directly onto a computer

**Pixel**   Short for picture element. A single point in a graphic image – in other words, small single-coloured square display element

**Pixelated**   An effect caused by displaying an image at such a large size that individual pixels are visible to the eye

**Placeholders**  Areas of a slide containing shortcuts to content, such as charts or pictures

**Playback**  Working through the pictures you have taken

**Ppi**  Pixels per inch – a measure of the resolution of a computer display, related to the size of the display in inches and the total number of pixels in the horizontal and vertical directions

**Programs**  Also known as applications – the files that allow you to work on a computer or control the system

**Receptors/photosites**  Parts of an image sensor receiving the light

**Resampling**  The digital process of changing the sample rate or dimensions of digital imagery by analysing and sampling the original data

**Saturation**  The intensity of a colour. A highly saturated hue has a vivid, intense colour, while a less saturated hue appears more muted and grey

**Screen tip**  A small box containing information about a screen item that has been selected

**Selection/marquee tool**  A tool that allows you to draw round part of an image so that it can be worked on alone

**Server**  A dedicated computer that handles particular types of files, such as email or web pages

**Sizing handle**  Small black or white box at the corner of an object that can be dragged to change its size

**Slow synchro**  In night-time shots Slow Synchro Mode slows the camera down and fires a gentle flash to balance the light in the shot

**SLR**  Single Lens Reflex cameras use a movable mirror placed between the lens and the film to project the image seen through the lens to a matte focusing screen. The photographer sees the image composed exactly as it will be captured on the sensor

**Software**  Programs run on a computer

**Task pane**  An extra window that opens up on Windows machines offering shortcuts to various facilities, such as managing files or searching for images

**Telephoto lens**  A lens with a long focal length normally used to make distant objects appear magnified

**Thumbnail**  Small-sized version of the pictures you are viewing

**TIFF**  Tagged Image File Format. A file format for storing images

**Title bar**  The top of a window – blue in Windows computers – showing the name of the file or program

**Toolbar**  A collection of tools that enable you to carry out particular tasks, such as drawing, formatting or working with pictures

**Tripod**   A camera accessory that allows you to fix your camera in a stable position

**TWAIN**   A standard for acquiring images from image scanners or cameras

**Uploading**   Sending files from your computer to the internet

**URL**   Uniform Resource Locator – the address of a web page (for example http://www.ageconcern.org.uk)

**USB port**   Universal Serial Bus is a standard means of linking devices. These have special connectors and are plugged into a receptor in the machine known as a port

**Wide-angle lens**   A lens whose focal length is substantially shorter than the focal length of a normal lens. You can get more into the shot and you tend to engage more with whatever you are photographing, getting closer to it

**Wizard**   A step-by-step on-screen guide helping you carry out a particular task

**Zipping**   Compressing files into an archive so that they take up less space when sent over the internet or stored on disk

# Index